THE MAGIC OF
OWLS

BY JOZEFA STUART

WITH AN INTRODUCTION BY ANGUS CAMERON

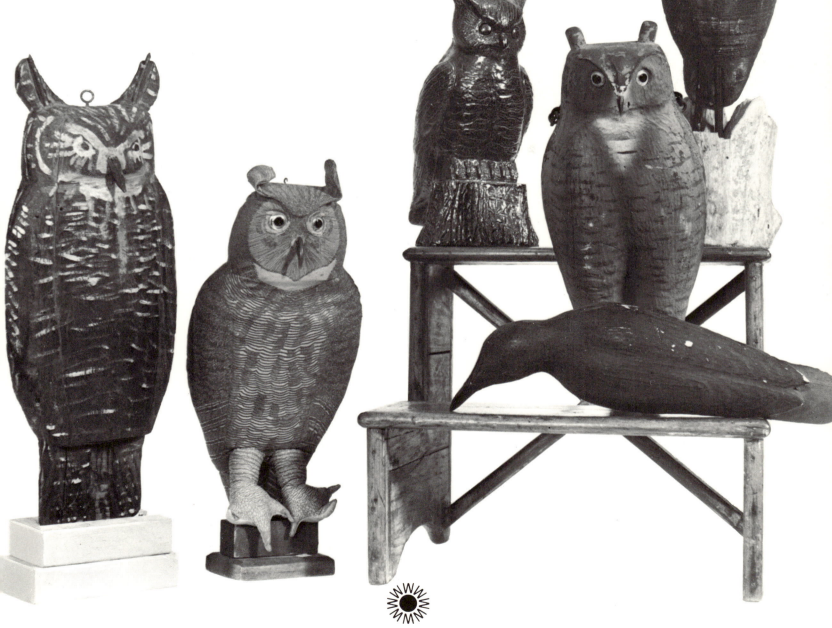

A WALKER GALLERY BOOK

WALKER AND COMPANY · 720 FIFTH AVENUE · NEW YORK, NEW YORK 10019

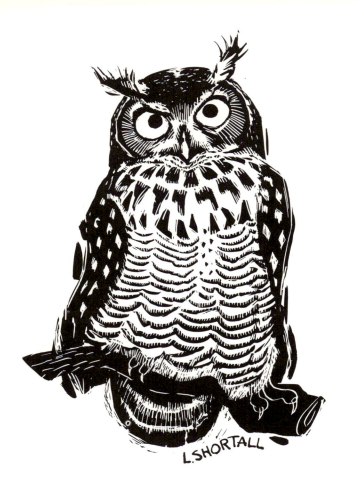

STAFF

EDITORIAL DIRECTOR: Richard K. Winslow

ART DIRECTOR: Barbara Huntley

MANAGING EDITOR: Andrea H. Curley

DESIGNER: Irene Friedman

RESEARCH: Susan S. Rappaport
Judith Szarka

PRODUCTION: David Kellogg

FRONT COVER: A folk art owl from Indonesia.

Courtesy, Far Eastern Arts Inc., photograph by Bo Parker, New York.

BACK COVER: Detail from a nineteenth-century panel of embroidered silk.

Courtesy, the Metropolitan Museum of Art, gift of the Citizen's Committee for the Army, Navy and Air Force, 1962.

OVERLEAF: A gathering of American folk art decoys.

Courtesy, Mr. Harold Corbin, Three Raven Antiques, Falls Village, Connecticut.

ABOVE: A personal interpretation of an owl by illustrator Leonard Shortall.

OPPOSITE: The owl is the symbol of Bryn Mawr College and sculpted in stone on its walls.

Courtesy, Bryn Mawr College.

First published in the United States of America in 1977 by the Walker Publishing Company, Inc.

Published simultaneously in Canada by Beaverbooks, Limited, Pickering, Ontario

Printed in Japan by Dai Nippon Printing Co., Ltd., Tokyo

Cloth ISBN: 0-8027-0578-2
Paper ISBN: 0-8027-7117-3

Library of Congress Catalog Card Number: 77-78130

10 9 8 7 6 5 4 3 2 1

Introduction

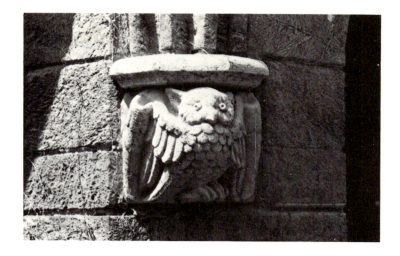

WRITING AN INTRODUCTION to this engaging book is like carrying owls to Athens, to use Swinburne's* fine phrase denoting superfluity. The book speaks for itself; the pictures speak for the owl as man has viewed this fascinating bird through the ages.

To many people an owl is an owl, and this is often especially true of the artists who paint or model this bird of the night. Owlishness is what is sought after, and often the owl in art is scarcely identifiable as to species.

The artist is more concerned with the spirit of the bird than with the genus or species, and to many artists an owl *is* an owl. If the work reflects the mysterious appeal of this bird, an appeal that dates back at least to the Upper Paleolithic, it is a sufficiency for the collector of representations of the owl.

Many collectors have never seen a live owl in its dark and eerie haunts. Owl collectors need not be ornithologists to pay homage to this bird's appeal. What collector would reject a Picasso owl because the great artist, godlike as most artists are in this regard, "evolved" his own owls. Picasso owls, like those of other artists, are owlish, and owlishness is what the collector is after.

What is owlishness, and why do collectors collect owls rather than robins, say, or wrens, or even crows. One might answer quickly, some do collect bird miniatures, porcelains that are not owls. Wildfowlers collect decoys; some householders have a gilt eagle over their door frame; roosters make fine weathervanes; and the Staffordshire potters do make handsome birds of various species. But owl figurines and the owl in the graphic arts are to be found gracing the shelves of whatnots on the walls of homes far more often than those of any other bird.

Although often held in folklore the world over as the bird of doom, of frightening portent and a familiar of witches, the owl also has apotropaic powers—the power to ward off evil spirits. It is common in magico-religious lore that the symbol of doom and disaster, whose appearance foretells the coming of evil events, may at the same time forefend dire consequence, guard against such evils. Such dual powers are especially inherent in the owl.

The owl's association with St. Martin (the Scots poet John Dunbar, contemporary of Chaucer, referred to the "Hornet Howle" as "Sanct Martynis fowle") exemplifies not only in the bird, but in the saint himself, apotropaic qualities. St. Martin's Day (Martinmas) which took the place of an ancient pagan festival, also inherited some of its usages and rituals and symbols. Although the medieval church inveighed against such "scotsales"—occasions of riotous and drunken celebration—it

*Swinburne stole the phrase from Plato, who undoubtedly saw many of Athena's owls on the Acropolis.

could not extirpate them from the folk custom. St. Martin, the very man who did so much to eliminate idolatry in his parishes and to whom Gregory of Tours attributed a list of 206 miracles the world over, became, nevertheless, in the permissive minds of the peasantry "the patron saint of drinking and jovial meetings;" and the owl, much earlier associated with drunken and frenzied revelry in pre-Christian, pagan ceremonial naturally became his symbol.

The celebrants, however, apparently ridden with guilt at making a holy man the patron of their pagan excesses, also attributed apotropaic qualities to the saint, for St. Martin was likewise in medieval lore the patron of abstemiousness and the patron of reformed drunkards.

The "owle," his symbol, had also long been associated with "the cure" as well as with the cause. A seventeenth century poet gave a remedy for dipsomania; it was raw owl's eggs that had the power to make a drunkard "suddenly lothe his good liquor." But in passing on this remedy it is likely that the poet himself did not know how far back in time lay the origins of his panacea. Philostratus, "The Athenian" (170-245 A.D.), passed on the Attic lore about our bird by commenting that the child who eats an owl's egg will never become a drunkard.

Edward A. Armstrong, to whom all who write of the folklore of birds (which happens to be the title of his fine bòok) are indebted, traces most logically the origins of this association of the owl with abstemiousness. The owl, Athena's favorite bird, was thus associated with the goddess's qualities, which were wisdom, thoughtfulness, clear perception, calm sobriety and good and wise counsel. We owe the saying "wise as an owl" to Athena.

But in the eighth century B.C. or thereabouts, during great social stress, an opposite and conflicting cult from the mystical Near East caught on in Attica—the cult of Dionysos. His "ecstatic, emotional and frenzied cult of inebriation and sexual license" challenged the calm rationality of Athena and her wise symbol. As Mr. Armstrong puts it: "The antidote of the fruit of the god's vine was therefore supposed to be the egg of the goddess's bird." "Keen-eyed," Athena thus challenged and brightened the bleary eyes of the worshipper of Dionysos, god of the vine and of wine.

The owl figurine that presides perhaps on today's

coffee table over a modern cocktail party can also preside over the hangover; the owl can thus represent the patron symbol of those who are on the wagon. No wonder the bird remains popular in modern households.

The worship of the owl as a magic symbol may well have antedated the worship of Athena herself, and by millenia. Some linguists believe that Athena herself derived from owl worhip—the symbol may have come before the goddess. The owl may well represent the totemic form under which she was worshipped in ancient times. The epithet *Glaukopis*, meaning "keen-eyed" in Homer, may originally, in earlier usage, have signified "owl-faced." The face we see on the obverse side (p. 6) of an Athenian drachma may have originally been the face of the owl goddess who predated Athena and became the anthropomorphized form of a primitive owl goddess.

We have seen in the Trois Frère rock engraving (p. 12) just how far back in time man's preoccupation with owls really dates, and how early he made artistic reproductions of the bird.

In the dim recesses of the Paleolithic, before our species possessed itself of the comfort of fire, the ubiquitous forces of nature were infinitely awesome. Storms, earthquakes, rain, hail, wind and flood, thunder, lightening, heat, and cold were frightening forces over which The People had no control. The primitive hords must have found the terrors of the unknown particularly frightful during the long nights when puny man always feels most vulnerable. The crescendos of the howling wolves, the voices of other great predators, all of which took stragglers from the company of our forebears, were terrifying enough. But among these night horrors came the cries of the owl. To all men, ancient and modern, the eerie hoots of great owls, their unearthly mutterings, their screams and screeches are especially frightening because the voices of this bird so closely resemble the capabilities of the human voice. Furthermore, the creature that uttered these horrendous night voices appeared somewhat like themselves, for did it not look one in the eye from both its eyes; did it not have ears like The People; and did it not stand upright. Perhaps the fact that it perched upright added most to its fearsome seeming kinship.

Examples of the owl's half-human fearsomeness are shown in the Eskimo sculpture of a creature half-man and half-owl on p. 43, and in the Northwest Indian mask (p. 38). But in addition to having a half-human *look* the owl's voice was also manlike. How many times over man's history has the awesome voice of the owl been associated with the dark moments of death of their own kind, for then as now the last moments of the sick, the injured, and the aged often come in the small hours of the night when bodily vitality is at its lowest ebb.

It is no wonder that the owl and its associated horrors should prevail in folk memory and, as magic evolved into religion, as the sensibilities of the species sharpened, it is not surprising that this bird of the shades should be associated with the creatures of their own medieval fervid and superstitious imagination. What better creature to associate with demons, devils, goblins, warlocks, and witches? Even the early churchmen, struggling to overcome the heresies of pagan religions, believed in such creatures, for were they not the earthly familiars of Satanic forces against which the church struggled for the souls of the damned? The owl became the visual surrogate of these devilish "entities." See Goya's use of the owl (along with the bat and cat) as a familiar of evil forces (p. 16). The plates of this book give rich sample reminders of how universal the powers of the owl have seemed to people everywhere the world over, and the facination the bird has always held for artists—from Magdelenian shamans who incised the snowy owls in stone at Trois Frères, to Audubon's charming watercolor, to Picasso's playful symbolism and on down.

But the imagination of the Folk and the carry-over of Folk memory into literature and art did not confine itself to the owl's association with death.

While all of us owl buffs—both those who collect figurines, prints, and paintings, embroidered owls or owls in macrame and those who are owl-watchers of the birds in their native haunts—love the "skeeriness" of owls, and treasure these folk memories of this bird of awesome portent, yet at the same time we love the wise old bird for himself. For us buffs, the wavering wail of the screech owl, the hollow, ventriloqual boom of the great horned owl, or the staccato barks of the barred owl are not only titillating to the neck-hackles but like the lonely, lunatic laughter of the loon are also a wonderful confirmation of solitude and poignant self-awareness.

Man, fellow creature of the owl, tends to forget the night bird's identification with "wo and myschaunce," evil portents, harbinger of death, and now thinks more readily of the beneficence of the wise old owl. But the Folk memories are not deeply buried. They lie shallowly in man's breast when he hears on a dark and stormy night the wild shrieks or dismal "hoo" of this bird. Such sounds become eerie echoes of times long past and a shudder of fear creeps down the spine of even the most blasé of moderns. He shares a moment of the same uneasy dread that his forebears felt, huddled together for comfort in some dark cave millenia ago when they, too, heard this same mournful wail.

So, when the modern collector looks upon the owl figurines on the shelves of his own owlery, he may properly consider them as symbols of life itself—as a portent of "wo and myschaunce" on the one hand, but of rationality and wisdom on the other. The owl has been with us for a long time, so long that the bird now represents the contradictory nature of man himself, a grand meld of the rational and the irrational, a mix of woe and wisdom.

—Angus Cameron

The coconut goblet in the shape of an owl (*opposite*) was made in seventeenth-century Germany. It is girt with silver and high-lighted by touches of gold. The head lifts off for drinking purposes.
Courtesy, Wadsworth Atheneum, Hartford, Conn.

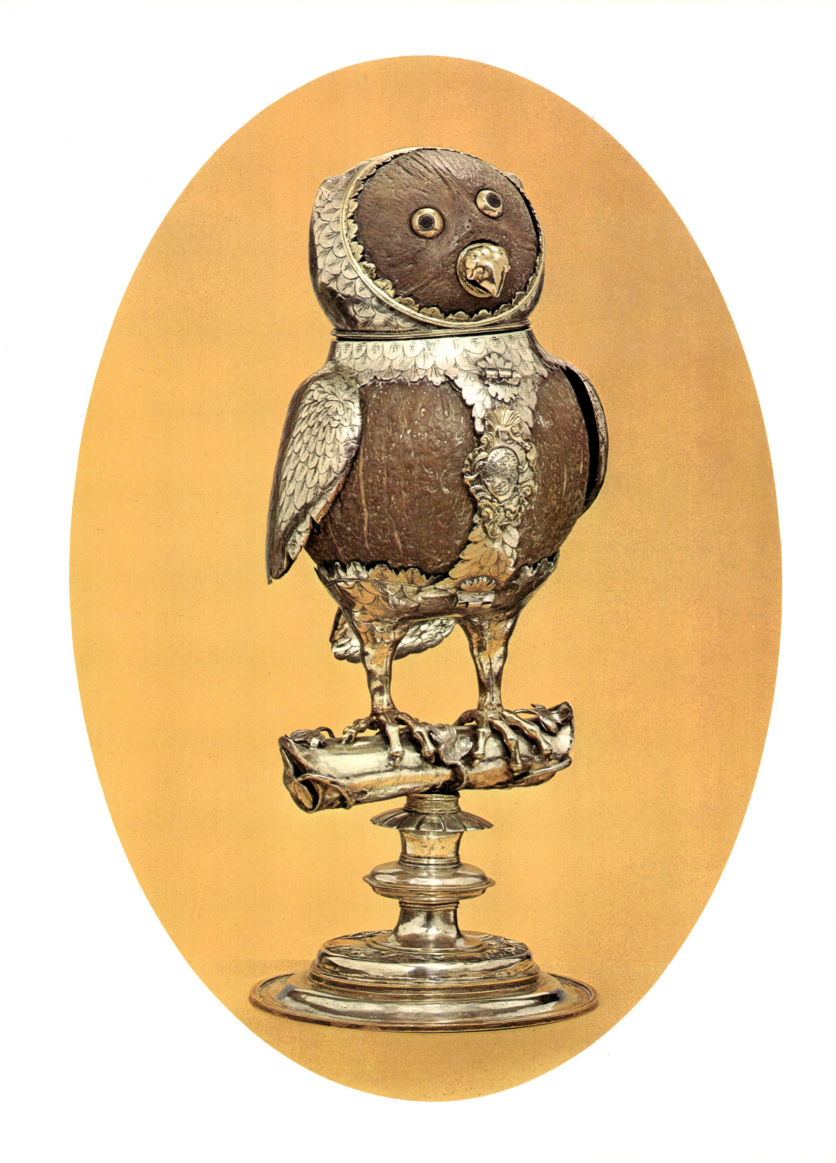

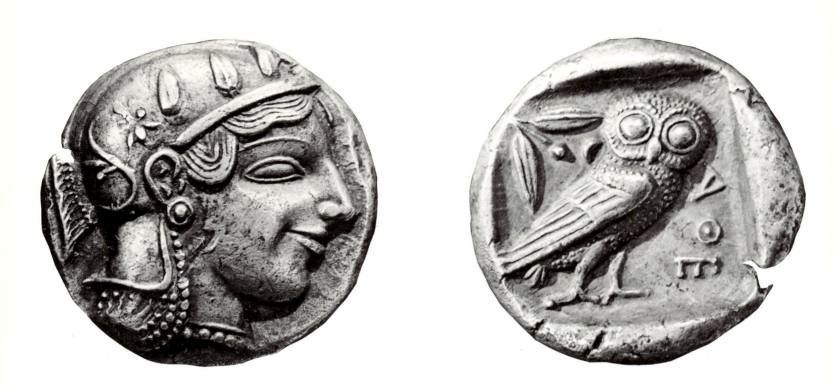

Athena and Her Owl in Greek Art

OF ALL ASSOCIATIONS between owls and deities, the most famous is that of the sacred owl of Athens (Little Owl), *Athena noctua*, and Pallas Athena, the Greek goddess of wisdom (*opposite*; bronze, fifth century B.C.). Originally, she may have been a pre-Hellenic rock goddess. If true, this could explain her connection with the owl, a creature of crevices.

Athenian coins of the fifth century B.C. were often stamped with the head of Athena on the obverse side (*above left*) and the Little Owl on the reverse (*above, right*). A tetradrachm coin of the second century B.C. (*below*) is distinguished by a large stamped owl with eyes of piercing intensity.

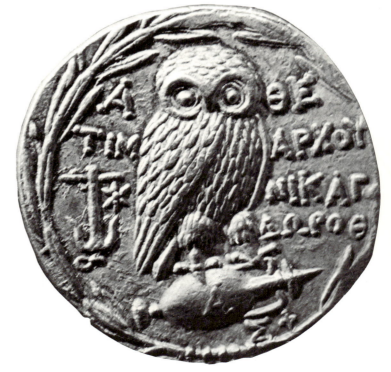

COINS; Courtesy, American Numismatic Society, New York
OPPOSITE; Courtesy, The, Metropolitan Museum of Art,
 Harris Brisbane Fund, 1950

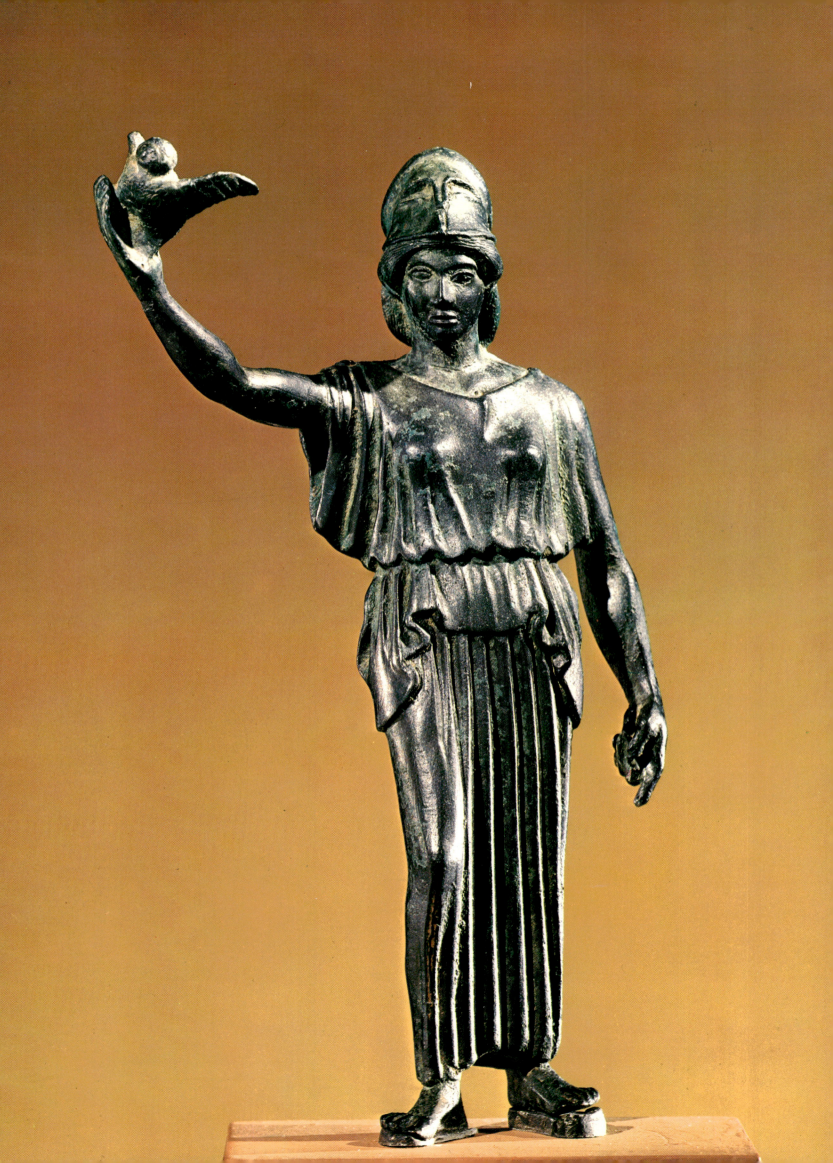

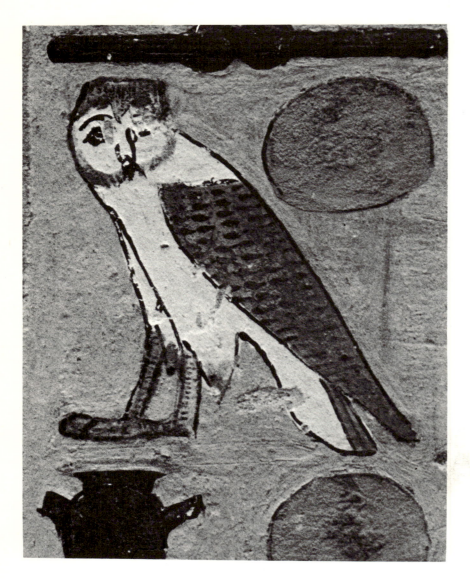

BENEATH A GOLDEN lotus tree, embroidered onto a nineteenth-century Chinese silk panel, (*opposite*) sits an ornately feathered owl, whose habitat seems more courtly than wooded. He enjoys the innocence of the protected in contrast to the painted owl (*above*) from the doorjamb of a tomb in Thebes, who has spent fifteen centuries guarding the soul of a dead Egyptian. Some three hundred years before they became the emperors of Germany in 1871, the Hohenzollern family proudly emblazoned the family coat of arms onto the chest of a pottery drinking vessel shaped like an owl (*right*).

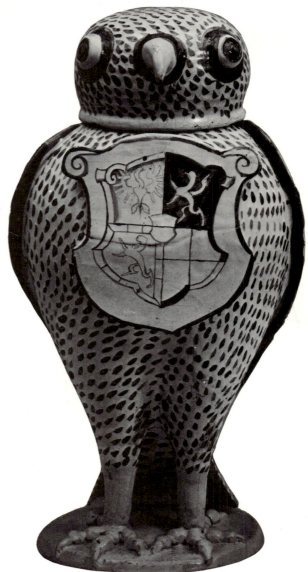

OPPOSITE: Courtesy, The Metropolitan Museum of Art, Gift of the Citizen's Committee for the Army, Navy and Air Force, 1962.
ABOVE: Courtesy, The Metropolitan Museum of Art, Rogers Fund, 1915.
RIGHT: Courtesy, The Metropolitan Museum of Art, Gift of R. Thornton Wilson, 1950, in memory of his wife, Florence Ellsworth Wilson.

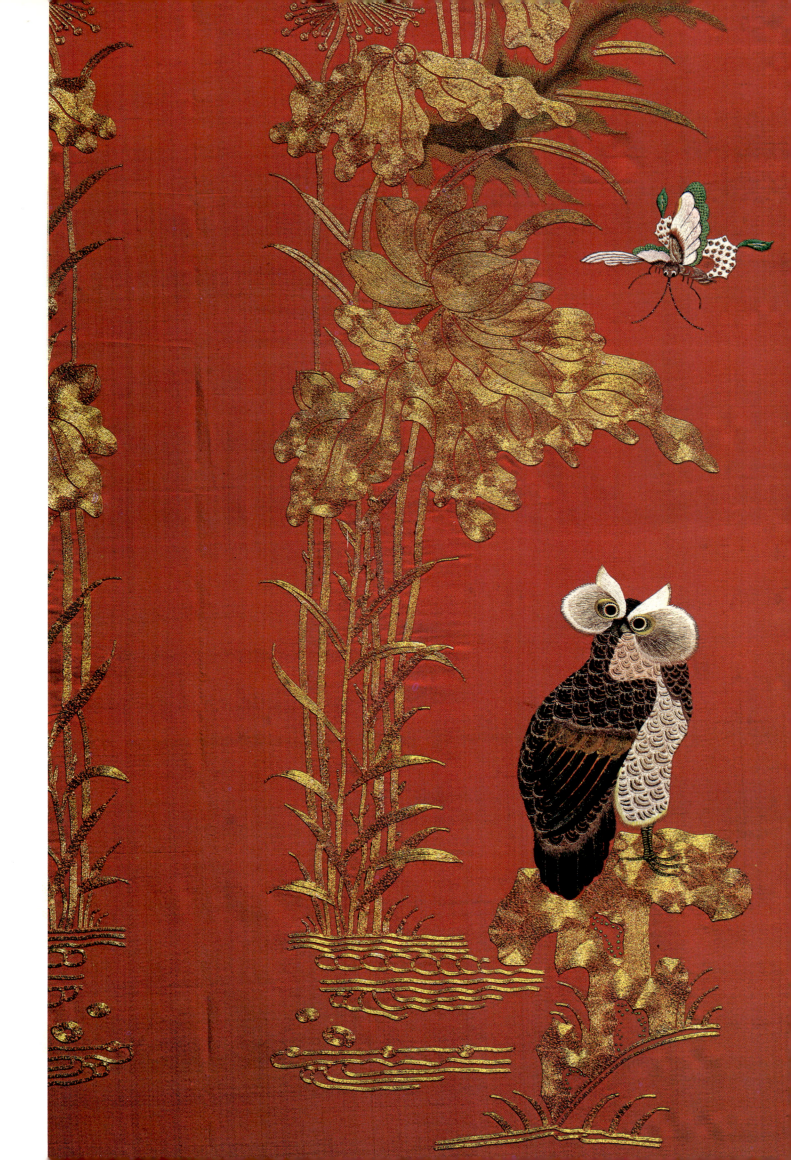

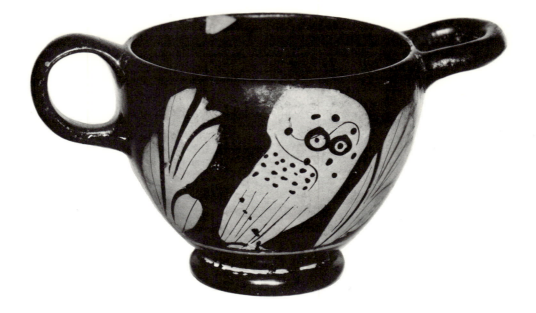

A Trio of Owls Across the Ages

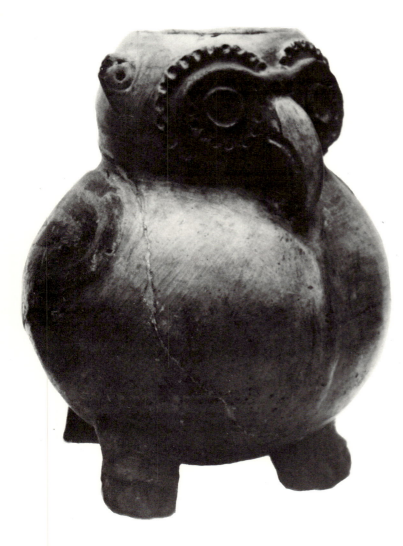

ACROSS THE centuries and across the world, the owl has remained a constant theme in art both great and small. The Athenians adorned a *kotyle*—so named for its two handles, one vertical, one horizontal—with a rendering of their cherished Little Owl. This particular example (*above*) was found in Apulia, southern Italy, telling us, two thousand years later, that this symbol of Athens had spread across the Greek Empire. On this continent, some one thousand years ago, an Indian of today's Costa Rica fashioned a sterner, fiercer owl (*left*) in the shape of an effigy jar. And in this century, Pablo Picasso's Little Owl (*opposite*) mirrors in bronze the wide, unblinking gaze of the original.

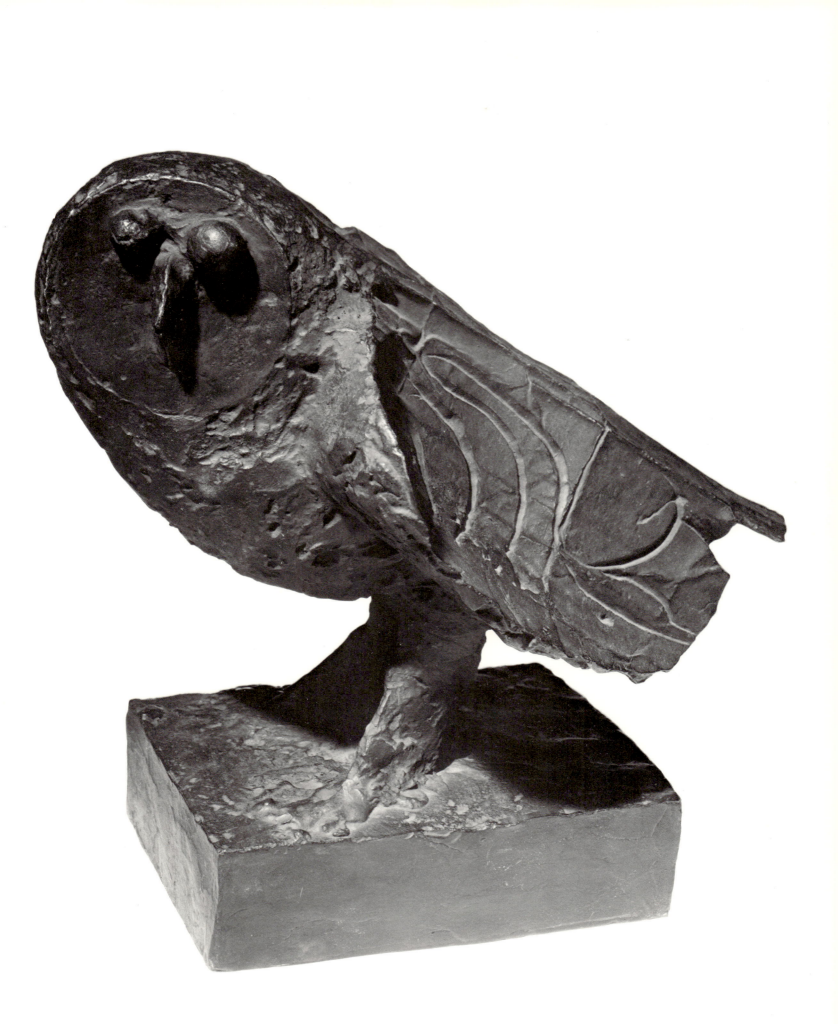

The Owl Preserved

TESTIFYING TO the antiquity of owls is this portrait (*below*) of a family of snowy owls. It was engraved on the walls of a grotto in France, anywhere from 35,000 to 19,000 years ago, at a time when an ice sheet covered Europe and the arctic snowy owl moved south. Although fossils have been found indicating that owls existed on earth as much as sixty million years ago, this rendering is the first-known portrayal of an identifiable bird. As it was found in an underground grotto that most likely served as a sanctuary for the primitive people of that day experts speculate that the bird had a religious, symbolic significance. When the great naturalist-artist John James Audubon came to paint his portrait (*opposite*) of a pair of snowy owls in 1829, he placed them dramatically against the massed storm clouds of a nocturnal sky.

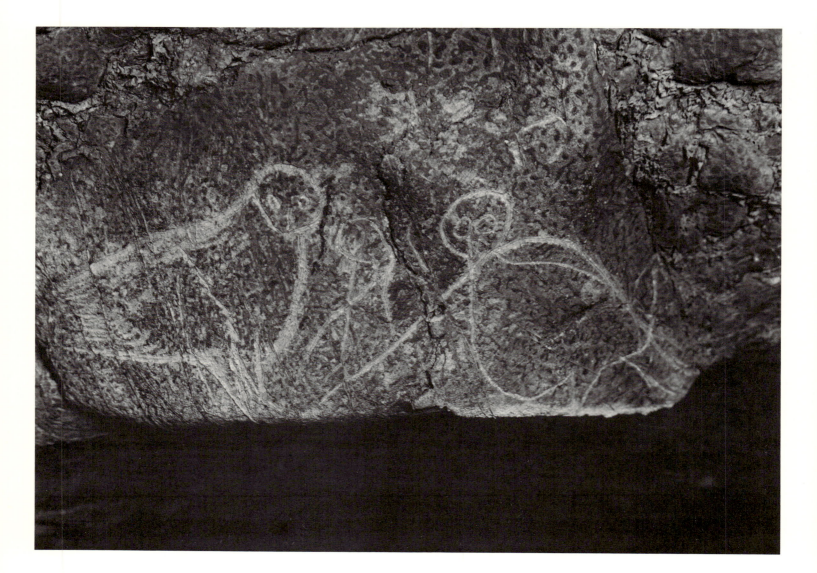

ABOVE: Courtesy, The Field Museum of Natural History, Chicago.
OPPOSITE: Courtesy, The New-York Historical Society.

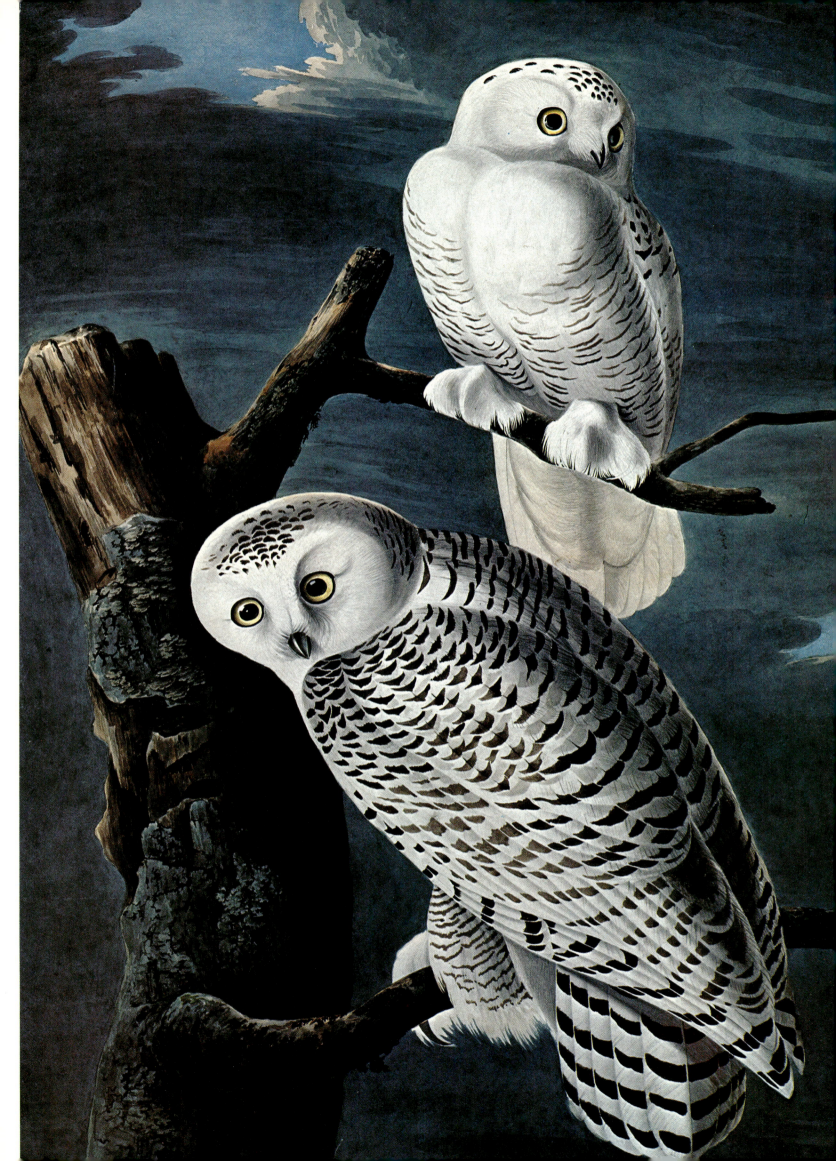

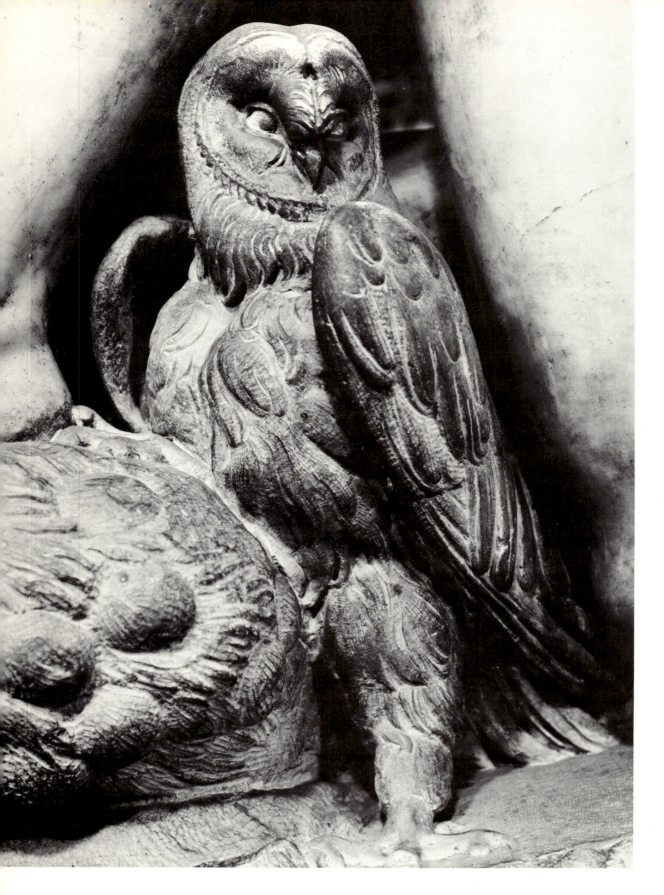

The Bird Who Digs the Grave

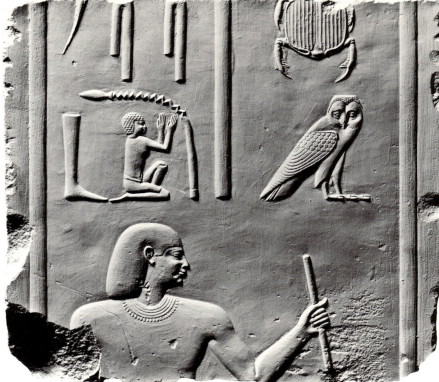

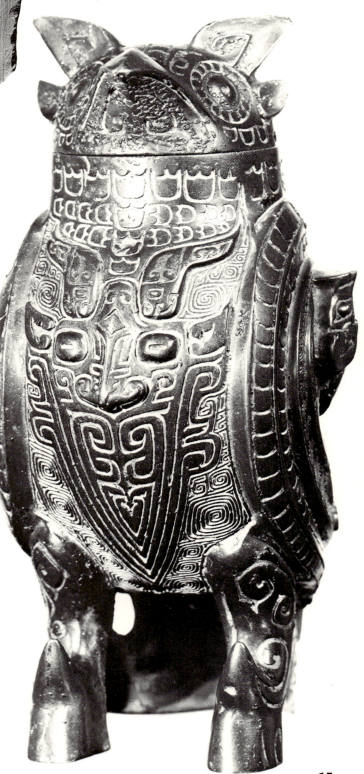

BECAUSE THE OWL is mainly a nocturnal hunter, myth and folklore often associate the bird with death. When Michelangelo sculpted the Medici tombs in Florence, during the early 1500s, he quite naturally placed a watchful marble owl under the knee of the tomb he named Night (*opposite page*). From the Chou Dynasty of China (12th-2nd centuries B.C.) comes the bronze jar (*right*). Records that would give the exact significance of the owl-inspired jar no longer exist, but, from the earliest days, the Chinese have attributed various special powers to the owl. It was known as "the bird who snatched away souls," and the hooting of an owl was described as "digging the grave." Egyptians incorporated the owl into their hieroglyphics. The bird (*above*) was carved in limestone some 2,600 years ago for the wall of a tomb.

OPPOSITE: Photograph courtesy, Alinari.
ABOVE: Courtesy, University Museum, University of Pennsylvania, Philadelphia.
RIGHT: Courtesy, Yale University Art Gallery, Gift of Mrs. William H. Moore for Hobart Moore and Edward Small Moore Memorial Collection.

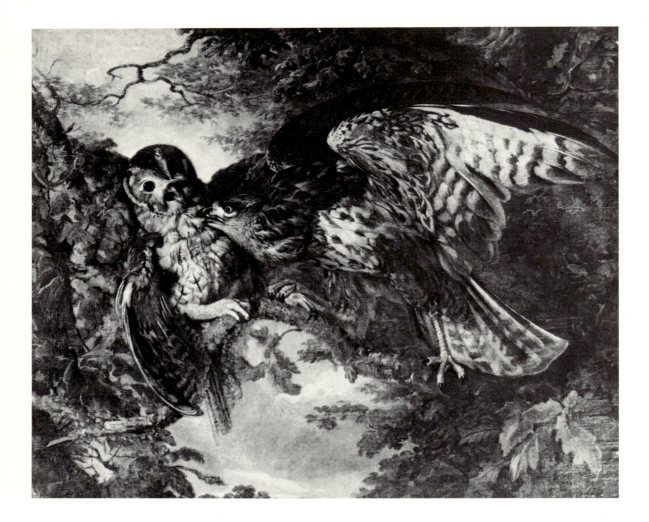

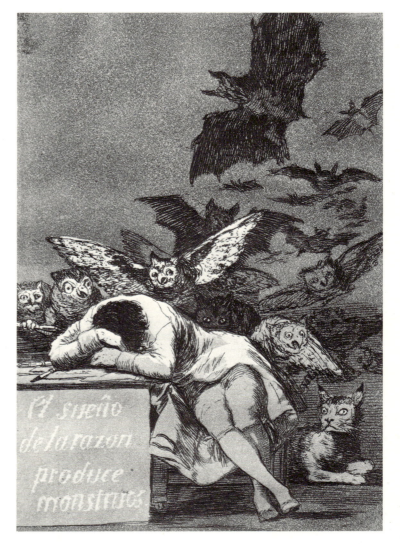

THE OWL, which is cherished by so many, symbolizes irrational fears and nightmares to others. In this engraving by the Spaniard Francisco Goya (*right*), the owl is linked with the bat as a threat to human tranquility. "When reason sleeps," runs the engraved motto, "monsters appear." The saw-whet (*opposite*) likes to live in damp, dark woods and hunt at dusk. Its victims are frogs and bats, but it also preys on its fellow birds so that they, too, can feel threatened by the owl. Francis Barlow, a seventeenth-century English painter, shows us an owl (*above*) being savaged by a falcon.

ABOVE: The Mansell Collection, London.
RIGHT: Courtesy, The Metropolitan Museum of Art, Gift of M. Knoedler & Co., 1918.
OPPOSITE: Photograph by Ron Austing.

16

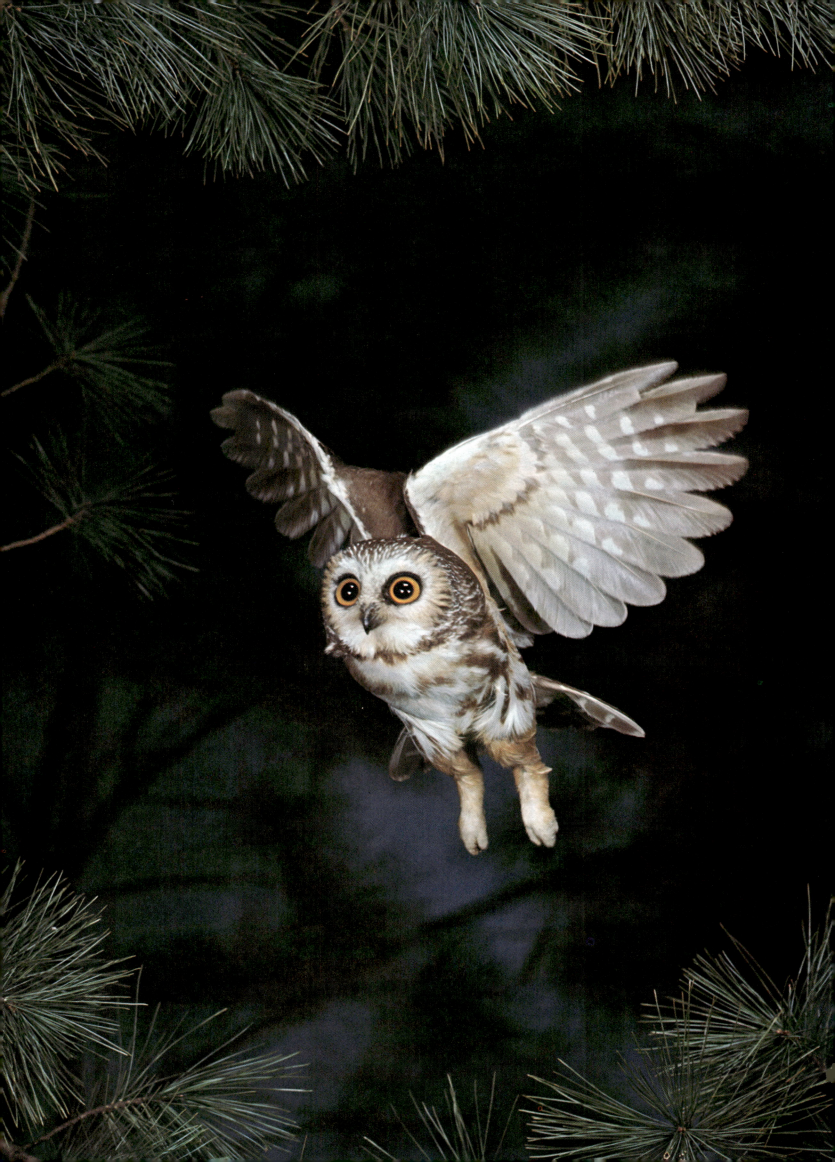

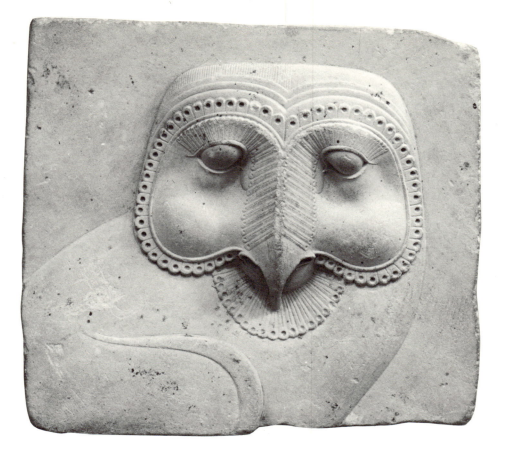

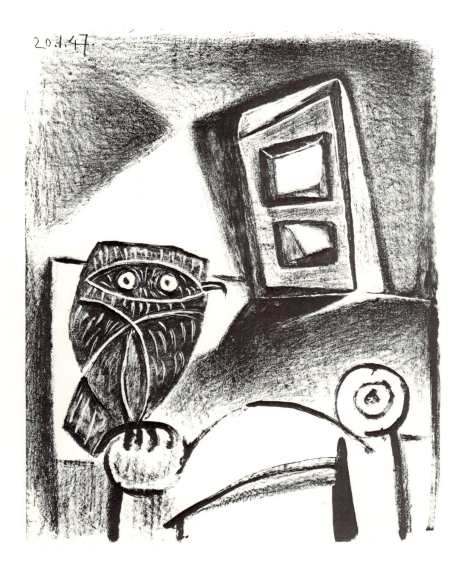

THROUGHOUT HISTORY, the gifted artist has often discarded the outward forms of nature but retained their essence to transform them into works of art. Thus, an unknown Egyptian sculptor of the sixth century B.C. (*above*) translated the owl's face into a delicately chiseled, mathematically balanced design in stone. In our time, Pablo Picasso and Leonard Baskin have used different mediums with the same intent. Baskin's meditative owl (*opposite*), carved in wood, echoes the bird's ancient and classical attribute of wisdom. Picasso, in a black-and-white lithograph (*left*) executed in 1947, places his owl in a domestic setting clinging to the back rail of a kitchen chair, which recalls an owl's natural perch.

ABOVE: Courtesy, The Metropolitan Museum of Art, Rogers Fund, 1907.
LEFT: Courtesy, The Philadelphia Museum of Art. Given by Henry P. McIlhenny.
OPPOSITE: Courtesy, Mr. and Mrs. Jacob M. Kaplan, New York.

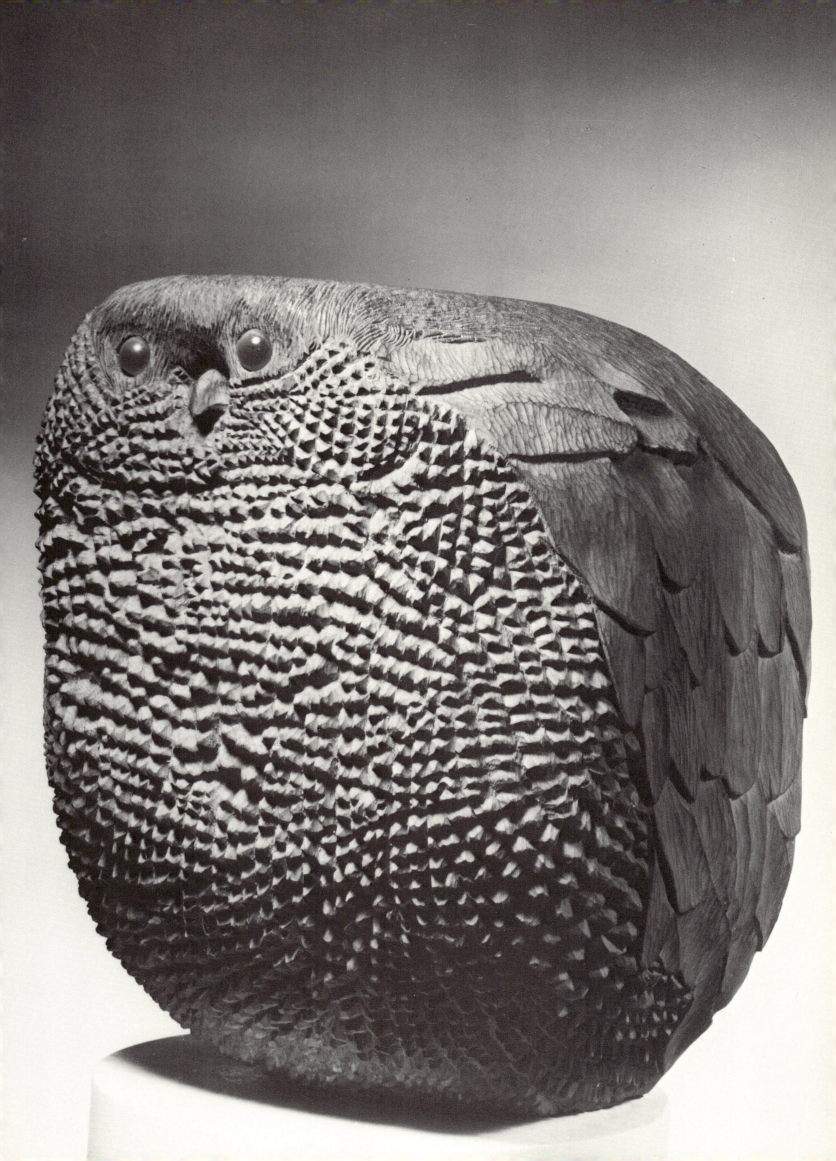

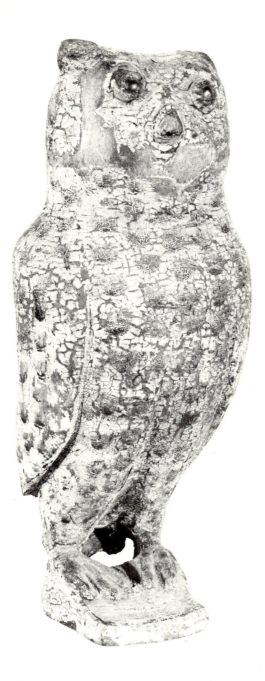

THE RANGE OF expression with which an owl can be
endowed is varied and limitless. The carver of the
wooden owl from Pennsylvania (*opposite*), which dates
from the nineteenth century, gave his bird a sharp,
curving beak and greedy talons to make him fearsome
and arrogant. The folk art decoy (*above*) has aged into a
vulnerable object with a broken nose and a coat of
grey-tinged white paint worn away by the years. Not
even two copper tacks for eyes can make this owl look
anything other than defenseless. The craftsman who
fashioned the Staffordshire glazed-stoneware owl (*right*)
in 1750 made him look mysterious, enigmatic and
handsome all at the same time.

ABOVE: Courtesy, Shelburne Museum, Shelburne, Vermont.
RIGHT: Courtesy, The Metropolitan Museum of Art, Gift of R.
 Thornton Wilson, 1943, in memory of his wife,
 Florence Ellsworth Wilson.
OPPOSITE: Courtesy, National Gallery of Art, Washington D.C.
 Index of American Design.

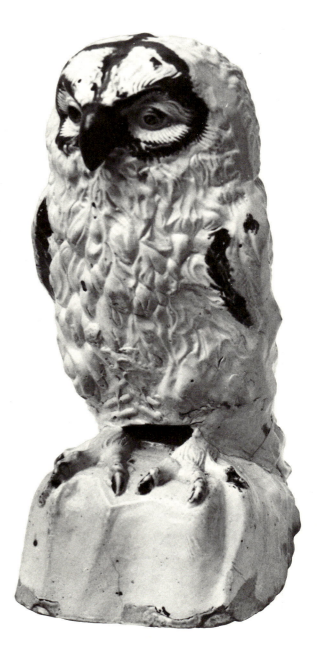

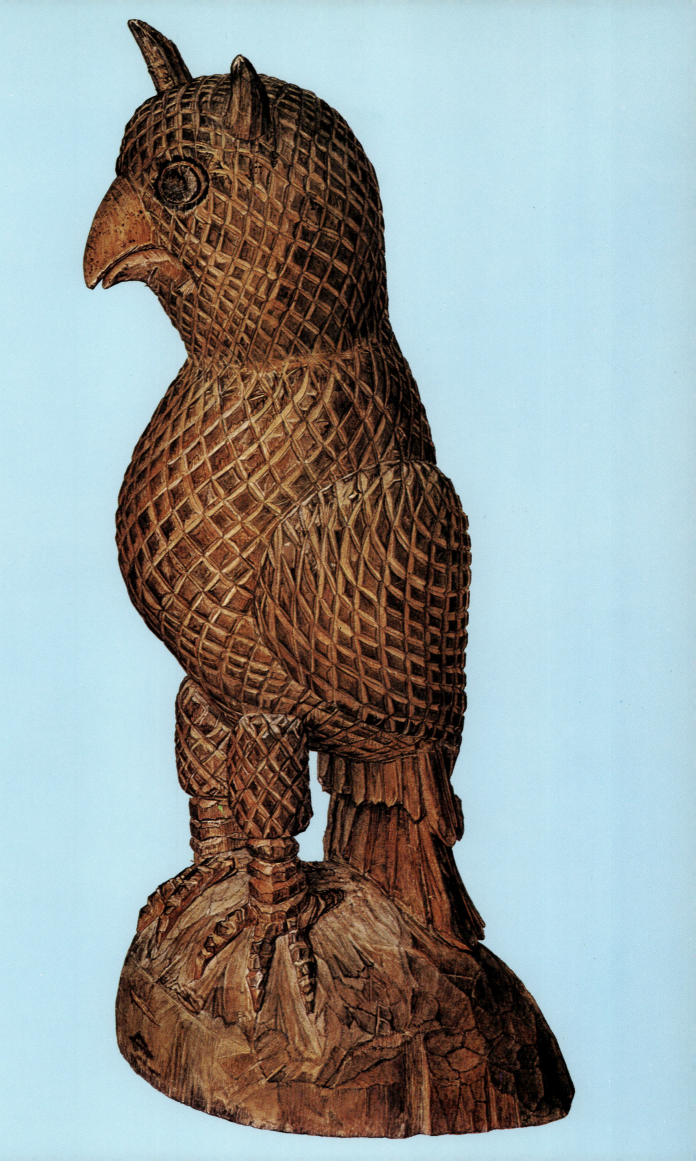

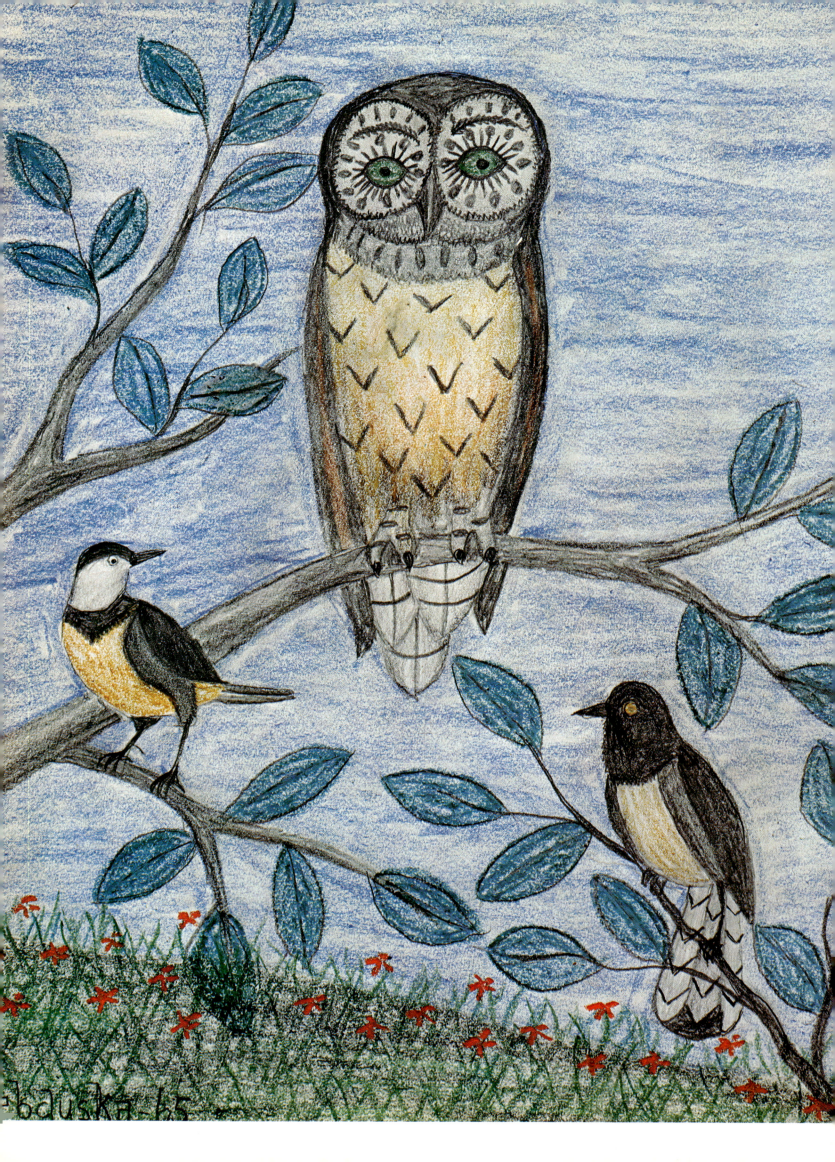

THE OWL IS a bird that is very much at home in the repertoire of the American folk artist. An unknown craftsman in the nineteenth century made an earthenware whistle of his owl (*right*); the bird emits a shrill peep quite unlike the haunting hoot of a live one. The twin decoys (*below*) are wooden cutouts painted in subdued colors to simulate real owls. No such intention motivated Lawrence Lebduska, a contemporary New York folk artist (*opposite*), when he honored a close friend by painting her as an owl. He gave her a commanding perch which allowed her to gaze upon the world with startling green eyes.

OPPOSITE: Courtesy, Collection of George E. Schoellkopf.
RIGHT: Courtesy, The Henry Francis du Pont Winterthur Museum, Delaware.
BELOW: Courtesy, Shelburne Museum, Shelburne, Vermont.

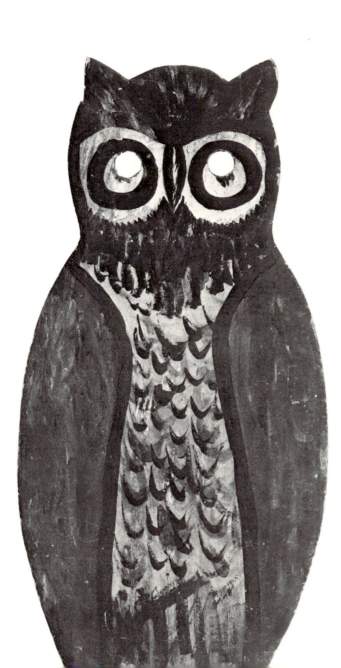

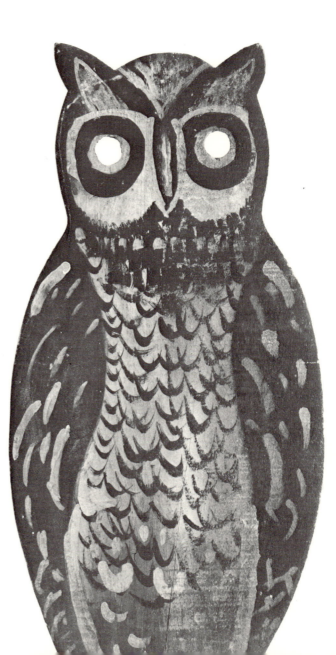

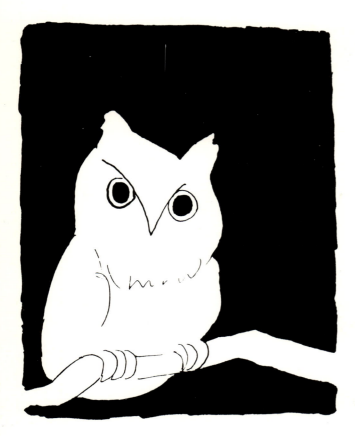

ALTHOUGH THE owl preys on other birds, he can at times be victimized by them. Kiosai, the Japanese artist who lived from 1831 to 1889, has given this theme a decorative rendering in his painting, *Owl Mocked by Birds* (*opposite*). James Thurber, whose owl (*left*) is the subject of his fable, *The Owl Who Was God*, satirizes the naive acceptance of the owl's wisdom by his fellow animals. Leon Karp's skillful brush strokes limn an owl (*below*) who glares at an invisible enemy.

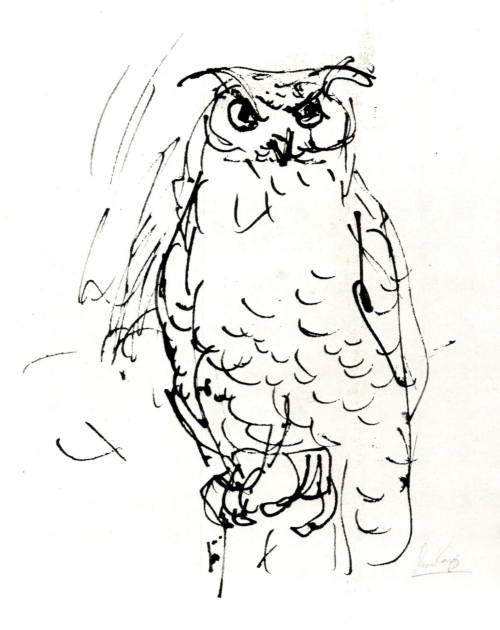

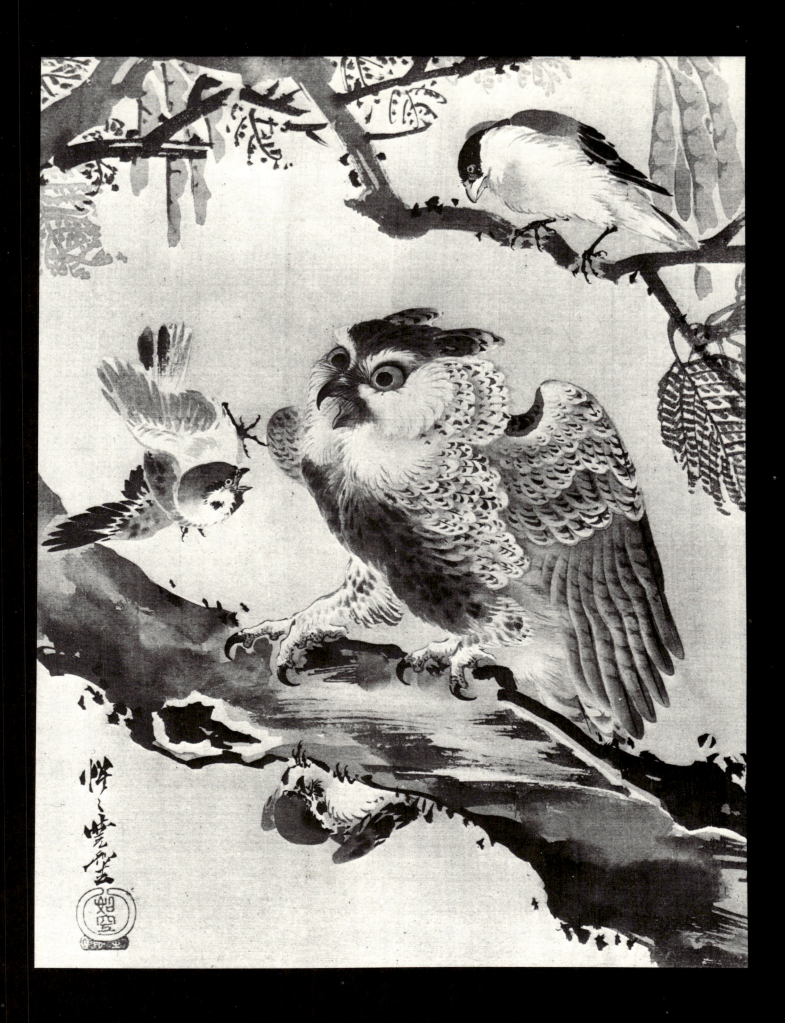

A Bevy of Vigilant Owls

THE EASTERN screech owl (*opposite page*) was a favorite subject of the great ornithologist John James Audubon, whose paintings of birds have been prized by Americans for over one hundred years. This trio of owls, looking especially vigilant, is a fine example of the work of Audubon, whose genius lay in his rare ability to combine scientific observation with artistic talent. Owls were popular with American folk artists. The wooden owl shown here (*right*) was probably carved in the mid-nineteenth century. Thumb tacks serve as eyes. The pair of owls (*below*) was painted on canvas some one hundred years ago. Their exaggerated staring eyes are yellow and black. This picture was done with a reason in mind—to scare away real birds from its place in an attic window.

RIGHT: Courtesy, Shelburne Museum, Shelburne, Vermont.
BELOW: Courtesy, Shelburne Museum, Shelburne, Vermont.
OPPOSITE: Courtesy, The New-York Historical Society.

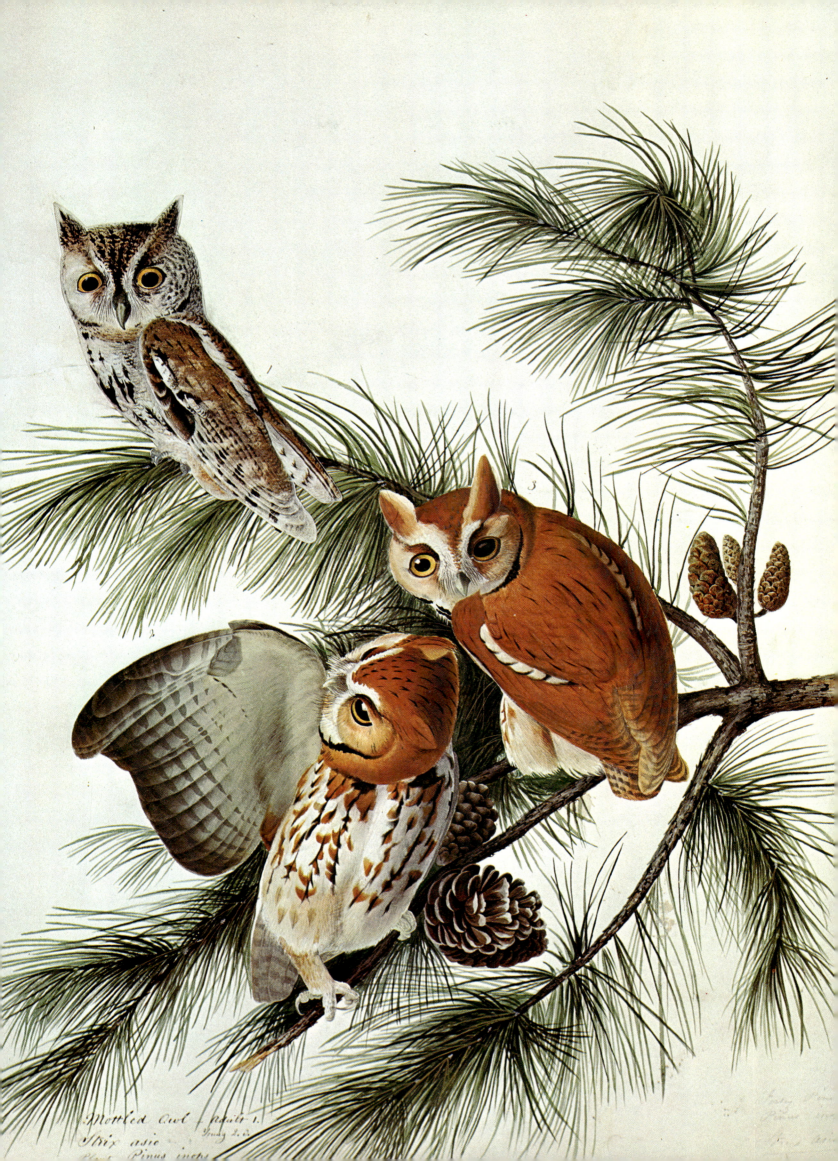

Mottled Owl. *Adult. 1.*
Young. 2. 3.
Strix asio
Plant. Pinus inops

FARMERS HAVE long prized the barn owl (*right*) for his skill as a hunter of rats and mice. In Europe a special door was sometimes built into a barn to entice him in. He likes to roost in churches and ruins, but a pair of these owls once lived in the Smithsonian Institution in Washington D.C. surviving on the rats and mice in the nation's capital. The barred owl (*opposite, above*) is recognized by his questioning cry: "Who cooks for you? Who cooks for you all?" The short-eared owl (*opposite, below*) hunts his mice during daylight hours in open fields.

ABOVE: Reprinted from *The Nightwatchers* with permission of Four Winds Press; © 1971 Peter Parnall and Angus Cameron.
OPPOSITE: Both photographs by Ron Austing.

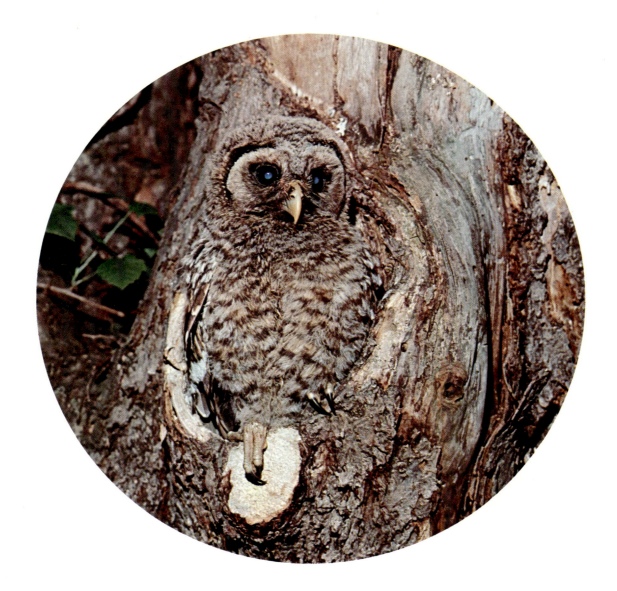

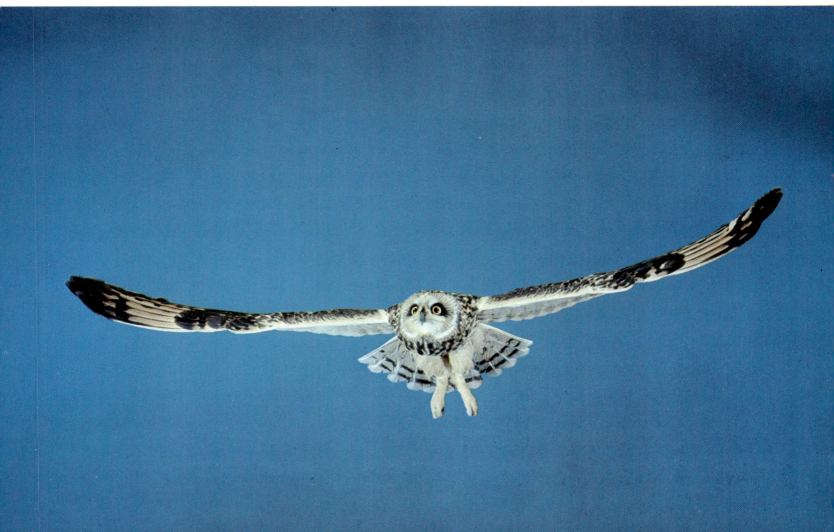

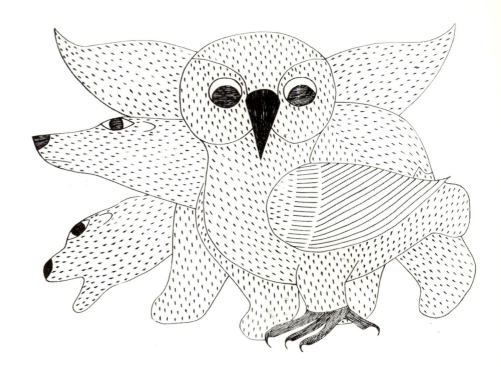

The Owl and The Eskimo

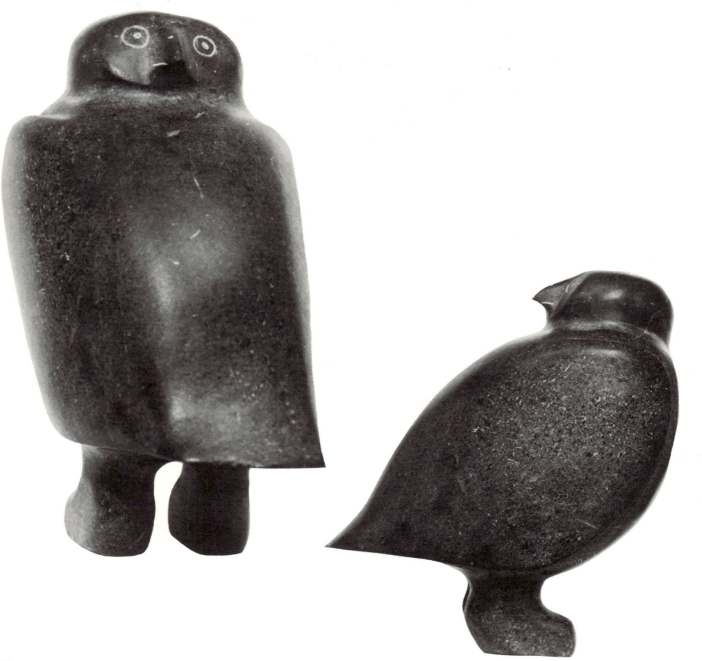

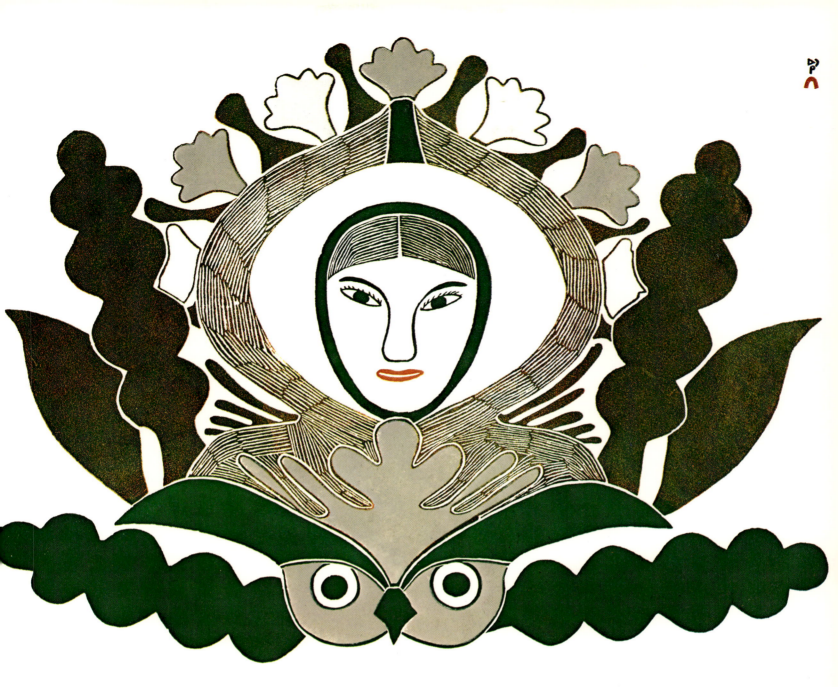

THE WHITE-FEATHERED snowy owl belongs to the Arctic landscape as much as robins and starlings are at home further south. Quite naturally, the snowy owl has played an important role in Eskimo art and mythology. The fanciful stonecut (*above*) is the work of Kenojuak, a prominent Eskimo artist. She titled her work *The Owl and I*, leaving her face disembodied above the bird. The simple little owl (*opposite*) is also her work , called *The Red Owl*. Eskimos have been carvers for more than two thousand years, using walrus ivory, bone and soapstone. The little black owl (*opposite, below*) viewed from both sides is the work of an anonymous carver of today. It is made of soapstone and has been painstakingly rubbed with whale oil to darken it.

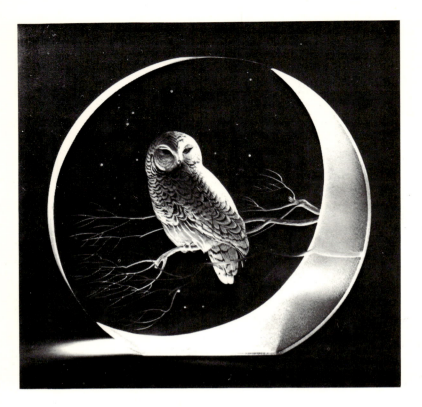

THE OWL has been carved in stone, cast in bronze, painted, engraved and also scuplted in glass. The crystal ornament (*below*) catches two baby owls looking vulnerable and defenseless. In the engraving on crystal (*left*) the Canadian James Houston has chosen to make his bird, the barred owl, look inscrutable and mysterious. Ivan Generalić, a contemporary primitive painter from Yugoslavia, renders his owl, (*opposite*) which is not identifiable as belonging to any specific family, in oils applied to a sheet of glass. Generalić, who was a peasant and herdsman in his childhood, has captured the bird's menacing swoop as it is about to descend on its prey.

LEFT AND BELOW: Courtesy, Steuben Glass.
OPPOSITE: From *The Magic World of Ivan Generalić* by Nebojša Tomašević, Rizzoli International Publications.

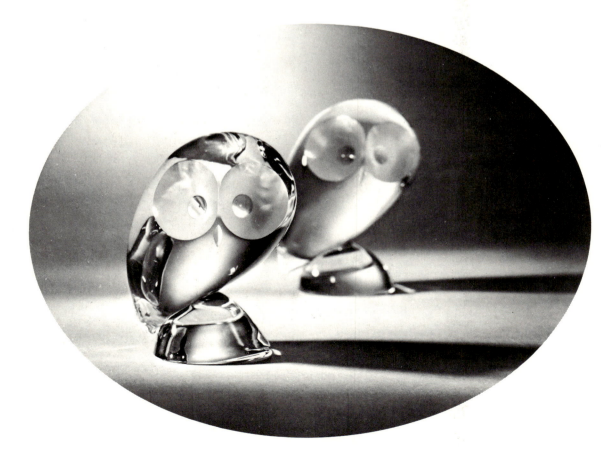

A Most Cosmopolitan Bird

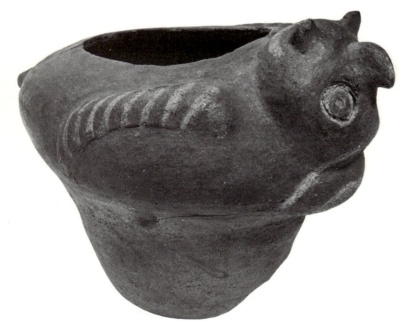

AROUND THE WORLD wherever the owl is found, its unusual markings, distinctive contours and near-human gaze has made it a subject with a strong appeal to artists and craftsmen. As much as two thousand years ago, a potter in Jalisco, Mexico, used an owl as a model (*below*) for a whistle. And a North American Indian, living in Florida one thousand years later, fashioned his redware pottery jar (*left*) in the image of the owl. Neither of these species is identifiable, but the ancestral commemorative carving (*opposite*) from New Ireland, a tiny volcanic island in the South Pacific, portrays three instantly recognizable barn owls. These birds are often described as the most cosmopolitan of all because they are found in so many different parts of the world, and are probably the most familiar of all owls.

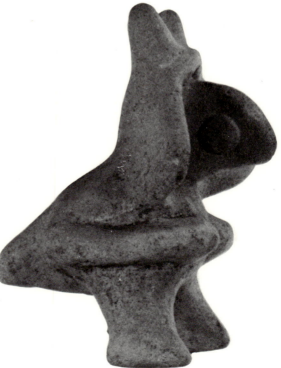

ABOVE: Courtesy, The Museum of the American Indian, Heye Foundation, New York.
RIGHT: Courtesy, Irene Friedman.
OPPOSITE: Courtesy, The Field Museum of Natural History, Chicago.

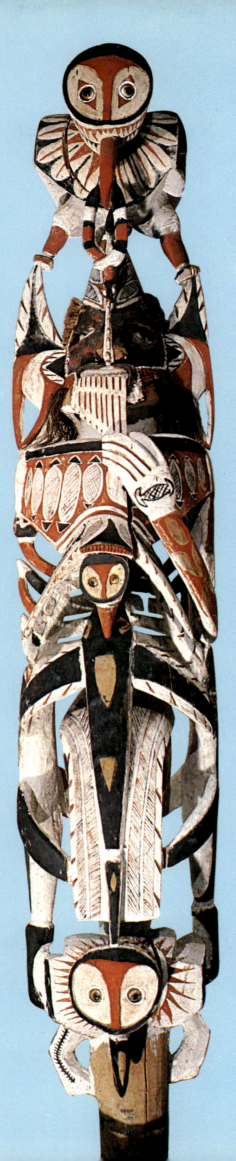

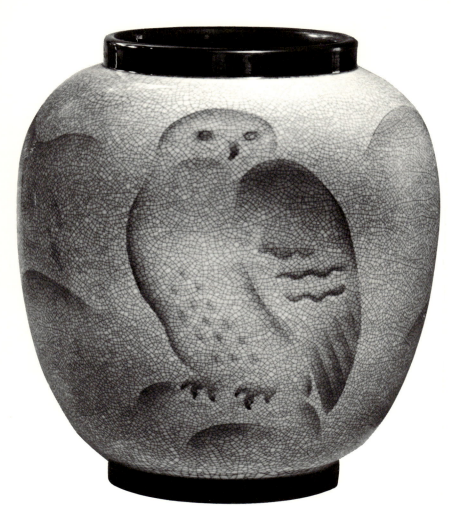

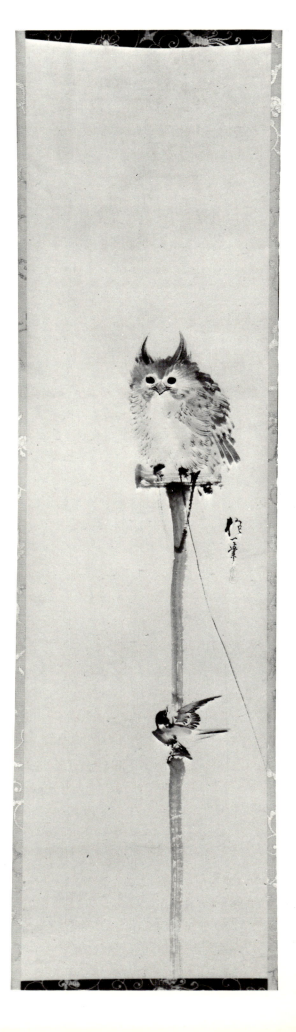

SOME FIND CHARM and appeal in the owl; to others it symbolizes disaster and destruction—no other bird has aroused such ambivalence in attitude and feeling. A ceramic jar from Denmark, made in this century, (*above*) shows us a tender, gentle, almost dovelike owl. And the Japanese printmaker, who perched his bird at the tip of a long pole (*right*), saw him as wise and disarming. Quite the contrary is true of the painting from India (*opposite*), executed during the Mogul Empire in the seventeenth century. Here, the owl is at his most rapacious and threatening; ignoring the horrified gaze of his fellow birds, the owl consumes one of their number.

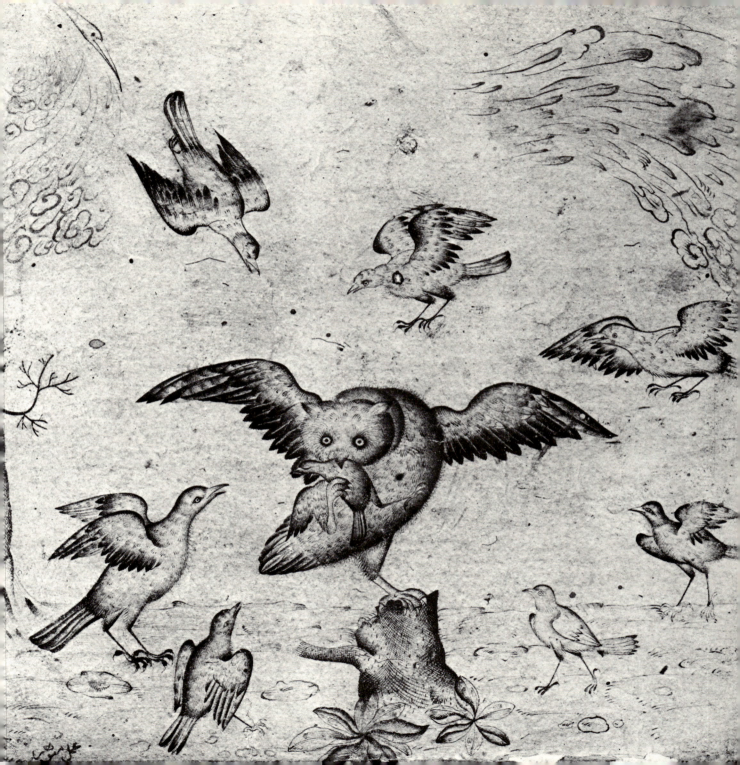

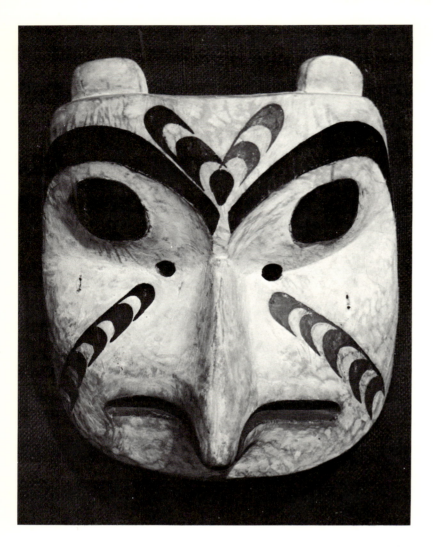

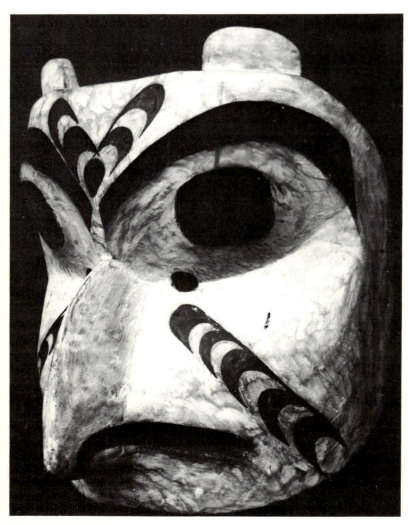

THE SIMPLE, strong lines of stylized evocations of the owl are among the most striking of all its portrayals. The mask (*left*), shown full-face and profile, is the work of American Indians of the Northwest. It was, most likely, intended to convey the essence of the spirit of the owl and was meant to be worn during ceremonial rites and dances. From the Ural Mountains (*right*) in the heart of the Soviet Union comes a highly-decorative and abstract portrait of an owl. It was incised by hand, on stone and subsequently polished and fired to create a high-gloss finish.

LEFT, ABOVE AND BELOW: Courtesy, The Museum of the American Indian, Heye Foundation, New York.
RIGHT: Private Collection.

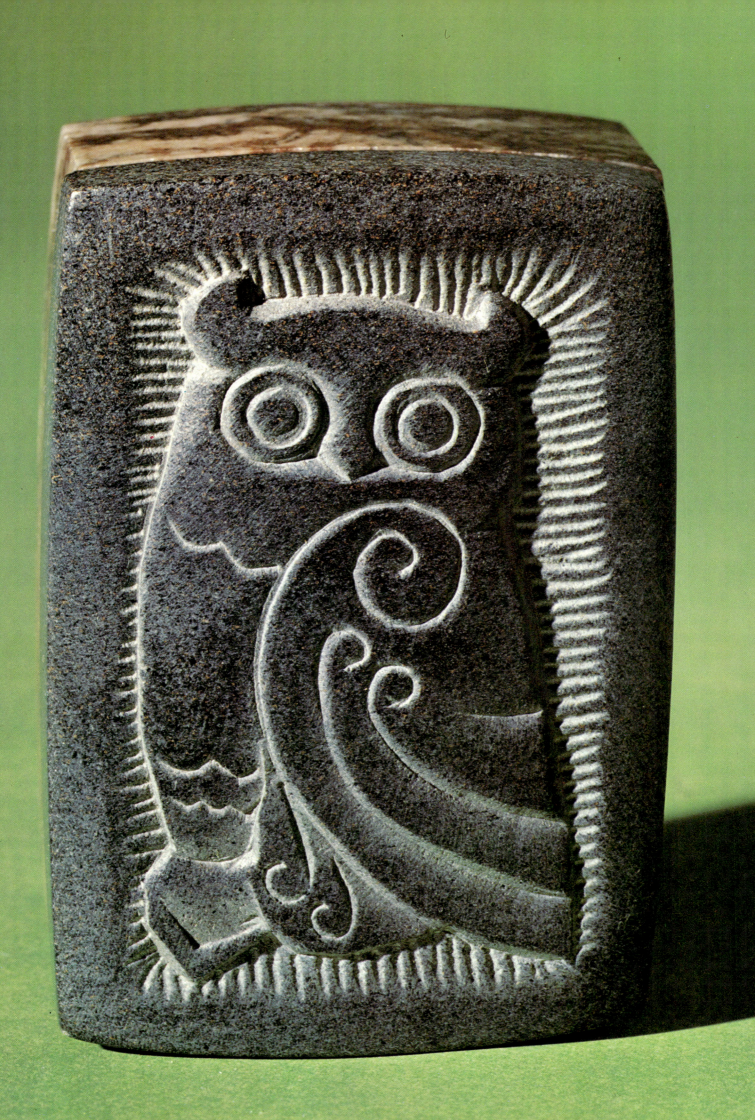

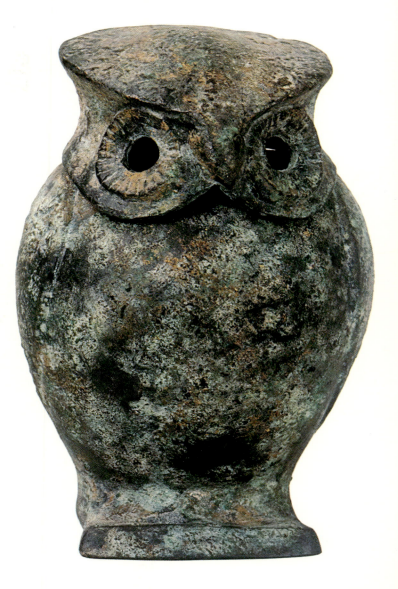

Owl Fantasies

IN FANCIFUL renderings of the owl, the artist has customarily endowed the bird with certain human traits. The gilded, papier-mâche owl (*opposite*) from Thailand looks out upon the world, proud and complacent, while the contemporary creature from Java (*above*) squints at the self-same world with suspicion and reserve. The lidded bronze jar (*right*), cast in Spain in the late eighteenth century, has transformed the owl into a practical object to serve a purpose—most probably the storing of a man's tobacco.

OPPOSITE: From the Collection of Wilson R. Gathings, photograph by Bo Parker, New York.
ABOVE AND BELOW: Courtesy, General Cigar and Tobacco Co. Division of Culbro Corp.

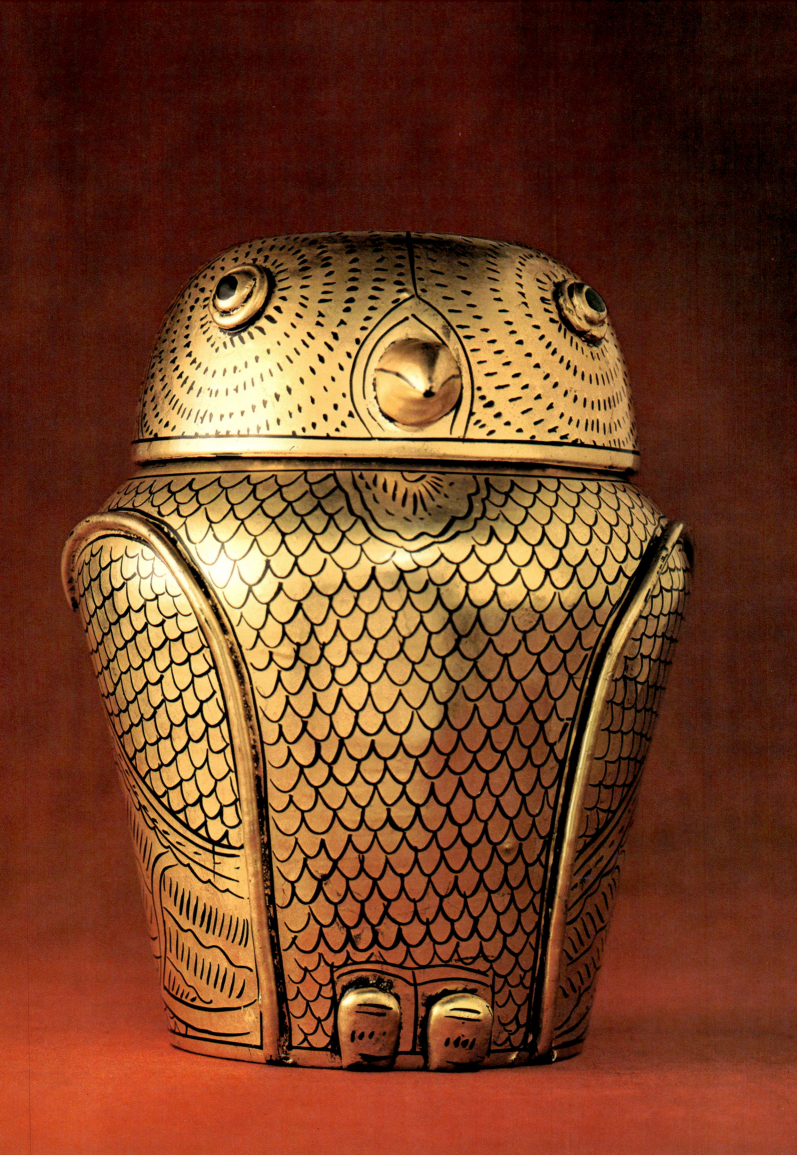

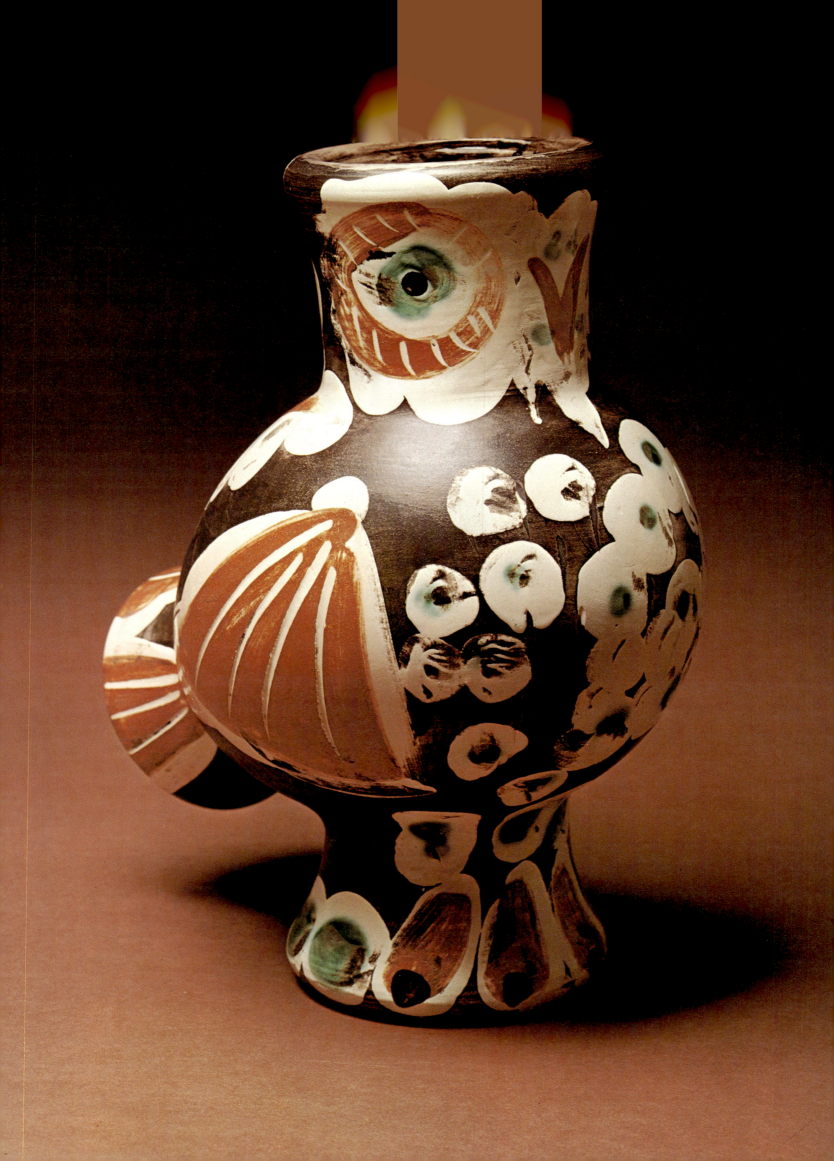

THROUGHOUT HIS life, the owl was a particular source of inspiration to Pablo Picasso. His jug (*left*) is an outstanding example of the artist's interpretation of nature and natural forms. Realism pervades the lithograph by M.E.D. Brown (*below*) of the great horned owl. Published in 1832 in one of this country's earliest natural history books, *The Cabinet of Natural History and American Rural Sports* by John and Thomas Doughty of Philadelphia, Brown based his illustration on an incident recorded by one of the authors: "One day last summer," he wrote, "about noon, I discovered one of these Owls feeding on a rabbit which it had just caught in a very retired wood . . . "

LEFT: Courtesy, The Ellen and Albert J. Feldman Collection.
BELOW: Courtesy, The Pennsylvania Academy of Fine Arts, Philadelphia.

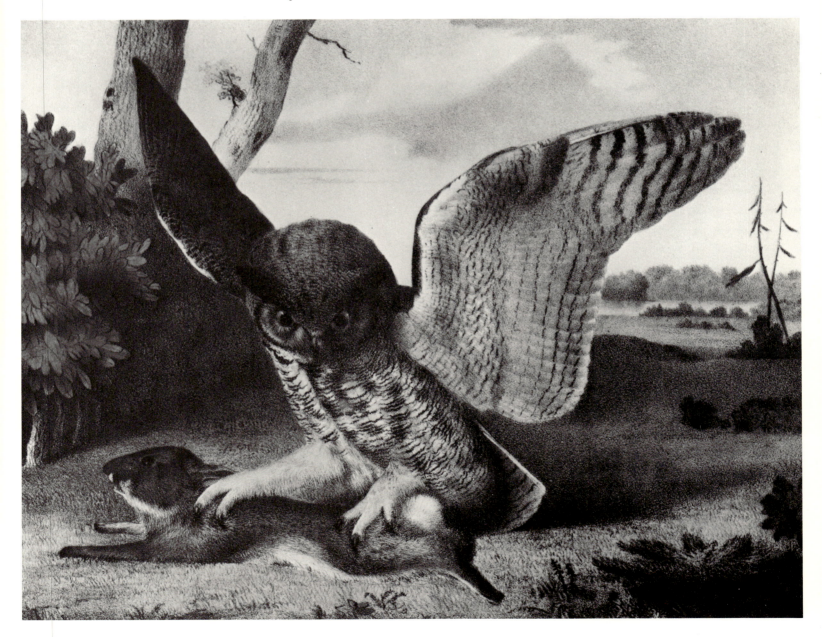

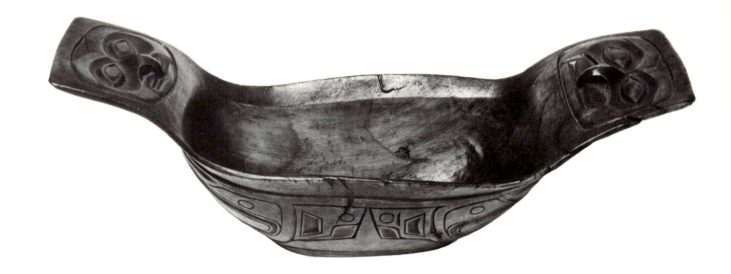

FOR MANY MILLIONS of years, the owl has inhabited the North American continent. From Wyoming and California comes fossil evidence which suggests that the ancestor of today's owl existed here some sixty million years ago. And the fossil bones of one individual owl that lived fourteen thousand years ago were recovered from a tar pit in Los Angeles. It is not surprising, therefore, to find that Indians and Eskimos have assimilated the owl into their designs and their mythology. Latcholassie, the contemporary Eskimo artist who sculpted the serpentine stone statue (*opposite*) interprets the ancient Eskimo belief that people turn into animals. His owl man remains half human. The Tlingit Indians of Alaska have incorporated an owl face (*above*) as a decoration in a dish carved of stone; and a representational owl (*below*) was painted on a Sioux shield used in a Ghost Dance in the late nineteenth century.

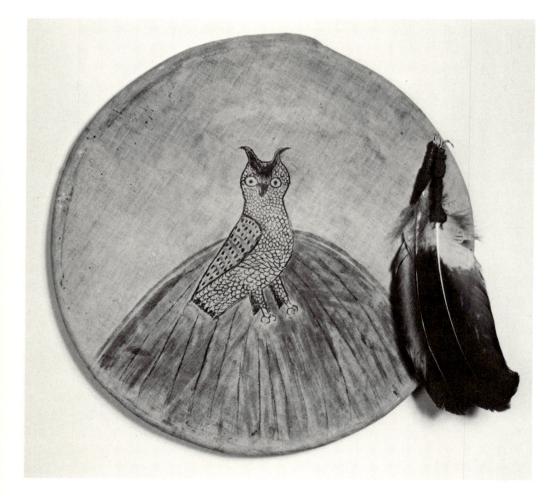

ABOVE AND LEFT: Courtesy, The Museum of the American Indian, Heye Foundation, New York.
OPPOSITE: Private Collection.

44

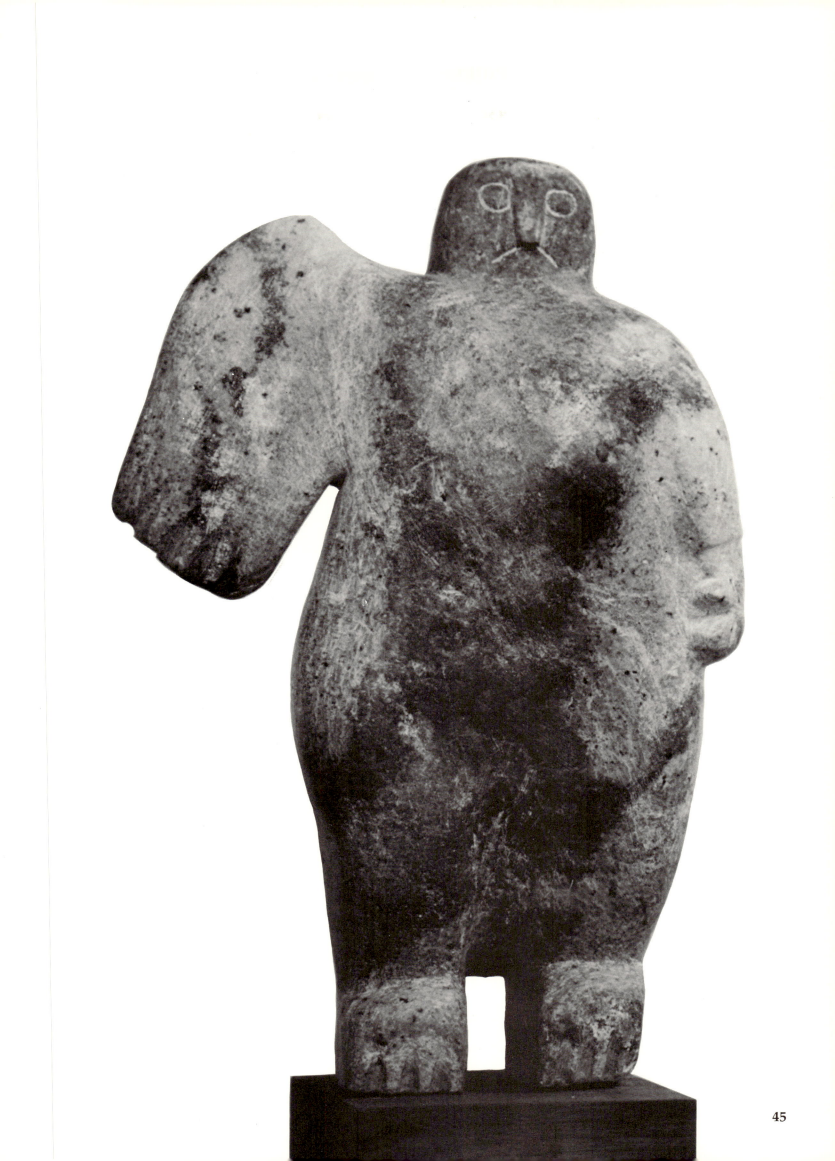

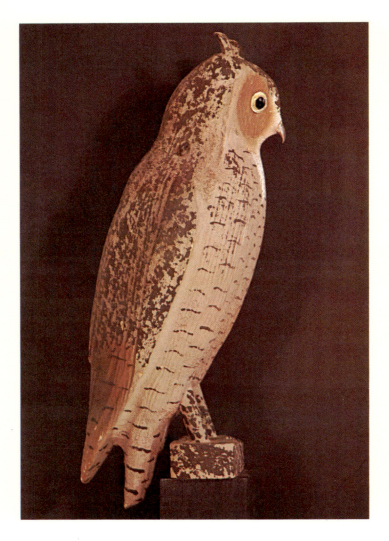 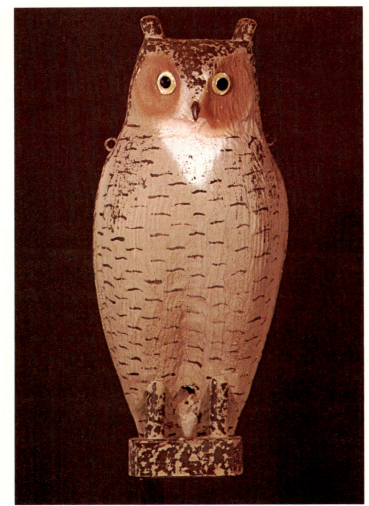

Owls Plain and Fancy

WHETHER THE intention behind the portrayal of the owl is purely decorative or, in contrast, practical and simple, the bird seems always to emerge as an object pleasurable to look upon. The wooden decoy (*above*) comes from Minnesota; despite its utilitarian purpose, the folk artist who carved and painted it produced a handsome replica of a real owl. A family of owls (*opposite*) made of ceramic clay reflects the classically American totem pole yet has been transformed by design and by a rich overlay of guinea hen feathers into a very contemporary ornament.

ABOVE: Courtesy, Sterling & Hunt, Bridgehampton, New York.
OPPOSITE: Courtesy, Paul Bellardo and Jeremie Hawley, New York, photograph by Otto Maya.

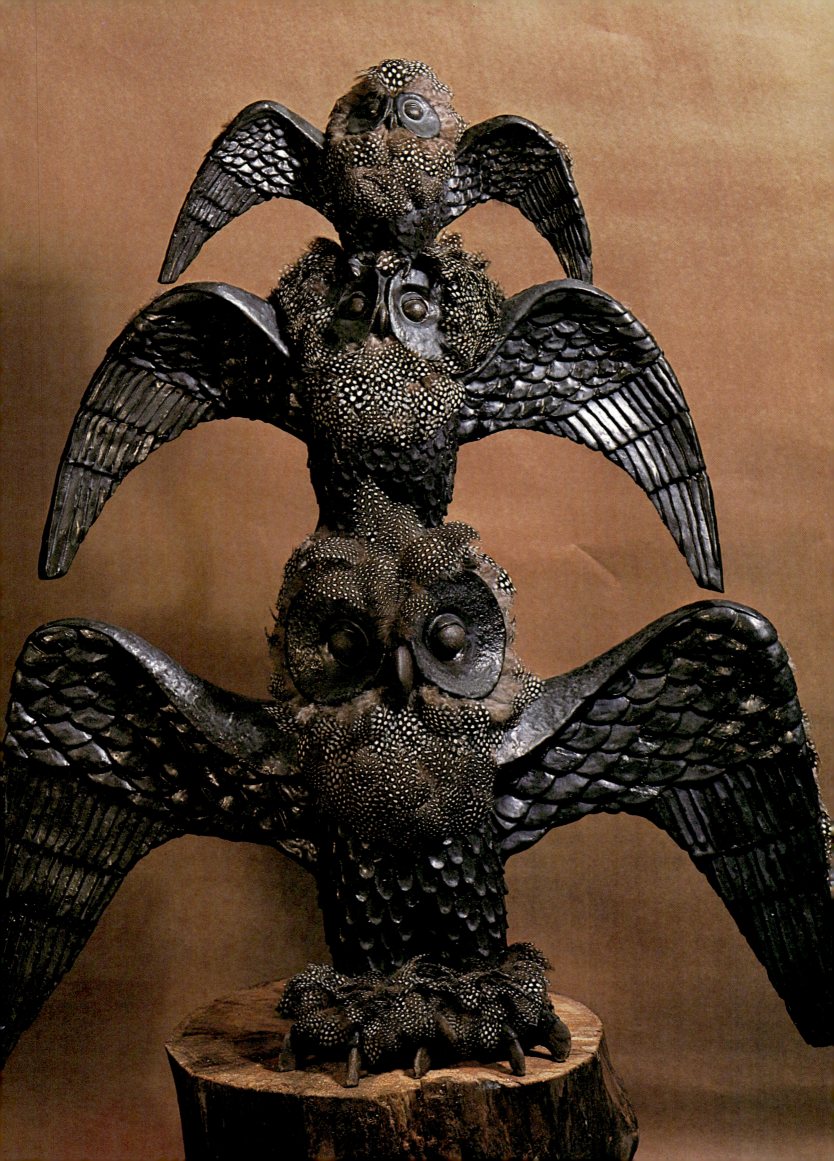

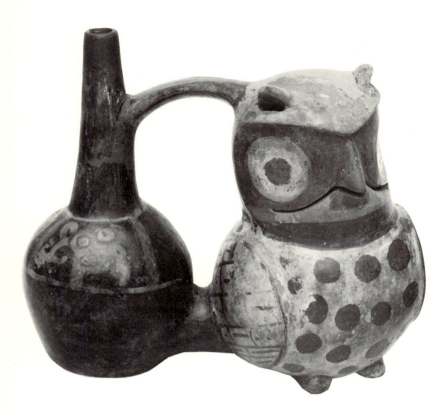

Owl Embellished Jugs

IN THE rural farming life of pre-Columbian centuries in South America, the owl was carefully observed and its habits and character recorded in the native arts. From northern Peru comes a second-century A.D. water jug (*opposite*). The Mochica Indians were farmers and, like farmers all over the world, grateful to the predatory owl for keeping mice and rats away from crops. The potter who fashioned the owl jar with a mouse in its beak may have been paying homage to the usefulness of the owl, while the Mochica Indian who hand-molded the effigy jar (*left*) in the shape of an owl man was paying tribute to a personage of local importance. The double jar (*above*) from the fifth century A.D. is southern Peruvian. Its creator, a Nasca Indian, embellished a simple earthenware water jug with the painted figure of an owl.

ABOVE, TOP: Courtesy, The Museum of the American Indian, Heye Foundation, New York.
LEFT: Courtesy, Irene Friedman.
OPPOSITE: Courtesy, The Art Institute of Chicago, Gift of Nathan Cummings.

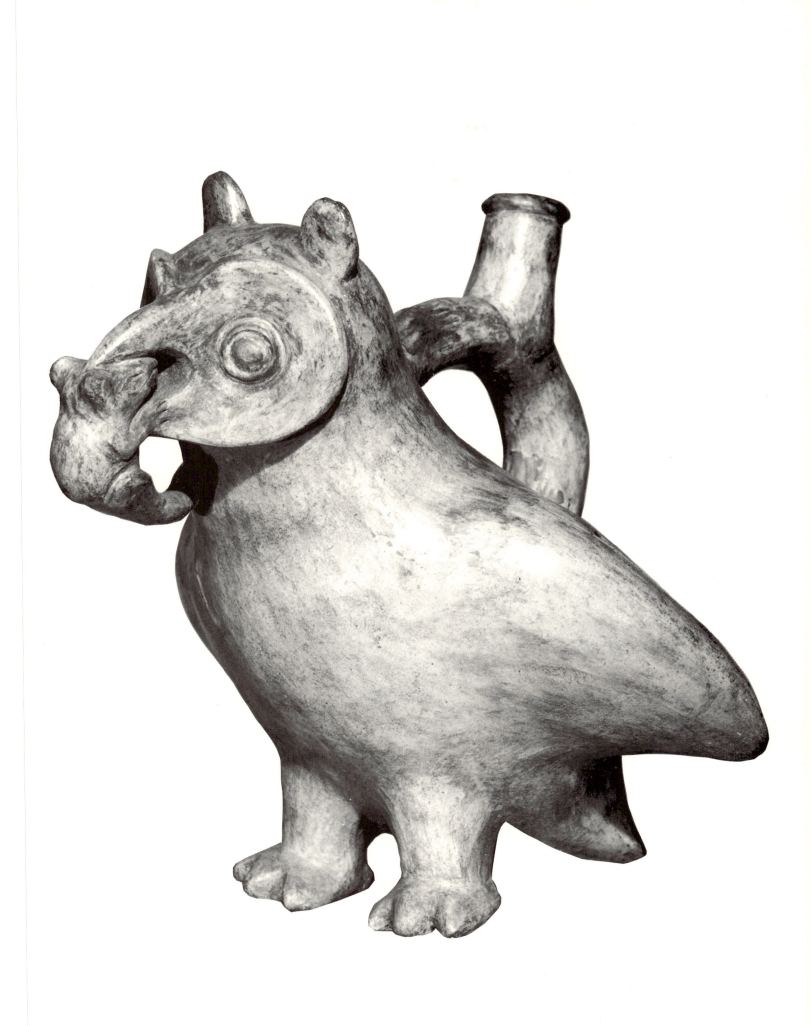

A Bird's Unblinking Gaze

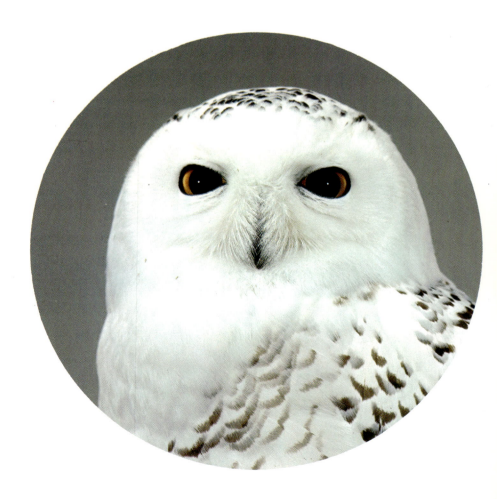

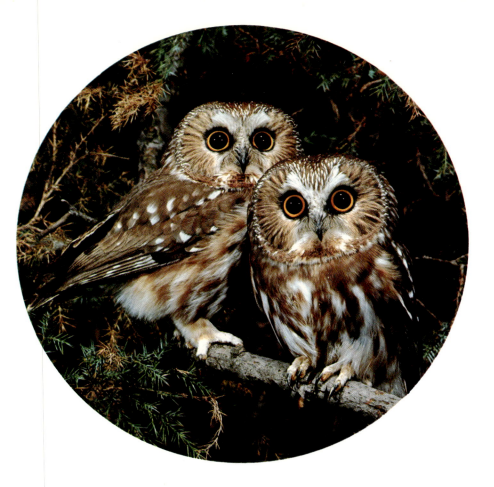

IN LARGE MEASURE, the fascination that the owl has exerted for countless centuries is due to the hypnotic, unblinking gaze he directs at us. The primitive paper cutouts (*above, left*), done one hundred years ago in New York state, convey this look exactly, as the real-life snowy owl (*left*) testifies. The twin saw-whets (*above*), so named for their mating call which resembles a saw being sharpened, are found only in North America. The round-eyed Kachina doll (*right*) was made by the Hopi Indians of the Southwest. It symbolizes the Spirit of the Owl.

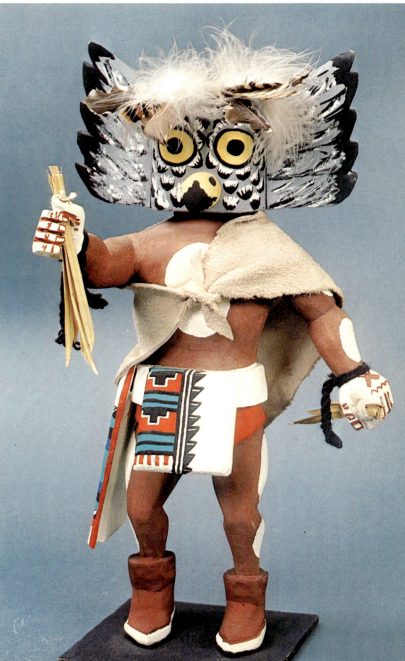

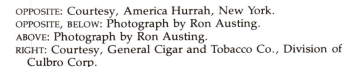

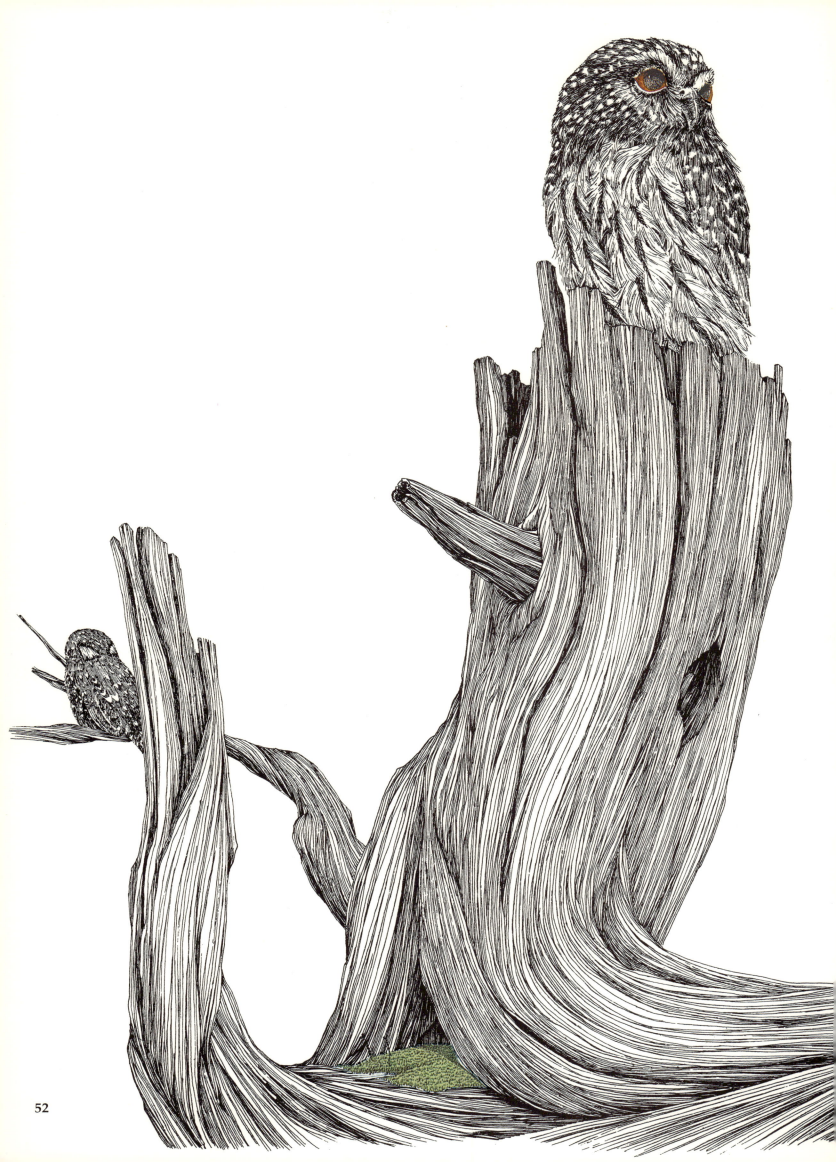

52

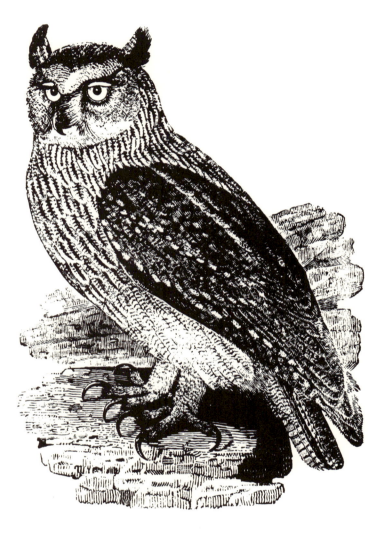

A FIERCE marauder, the eagle owl (*right*) is among the most predatory of all owls, powerful enough to kill deer and foxes. Its eagle-like beak and strong talons are realistically portrayed in this wood engraving by the English illustrator and naturalist Thomas Bewick. The pygmy owl (*left*) is a pugnacious little 6-inch bird, ever ready to tackle prey larger than itself. The various and numerous species of pygmy are found throughout the world from the savannahs and equitorial forests of Africa to the jungles of Brazil. Peter Parnall's drawing is of the American species, which ranges from Canada to Guatamala.

LEFT: Courtesy, The Greenwich Workshop Inc. copyright 1972. Reprinted from *The Nightwatchers* by permission of Four Winds Press; © 1971 Peter Parnall and Angus Cameron.
RIGHT: From *A History of British Birds*.

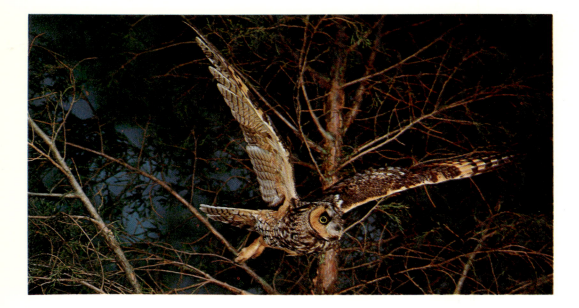

THE LONG-EARED owl (*above*) is a bird that hunts at night. During the day it hides in dense cover to emerge at night in search of voles, mice and other small mammals. Although this bird is only 15 inches long, its wingspan measures up to 40 inches, giving it a menacing look in flight. A brood of baby screech owls (*below*) nestles against a tree trunk that affords them protective camouflage. The adult screech owl (*opposite*) varies in color from grey to reddish; it lives on insects and because of this is threatened by the spread of insecticides.

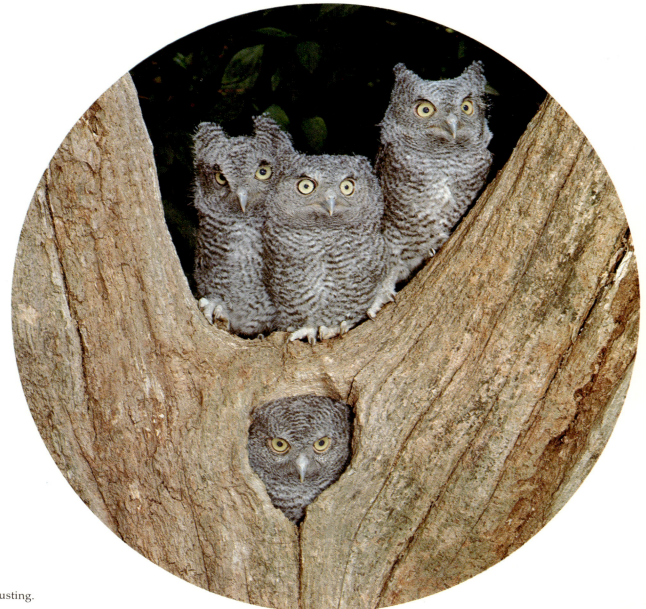

All photographs by Ron Austing.

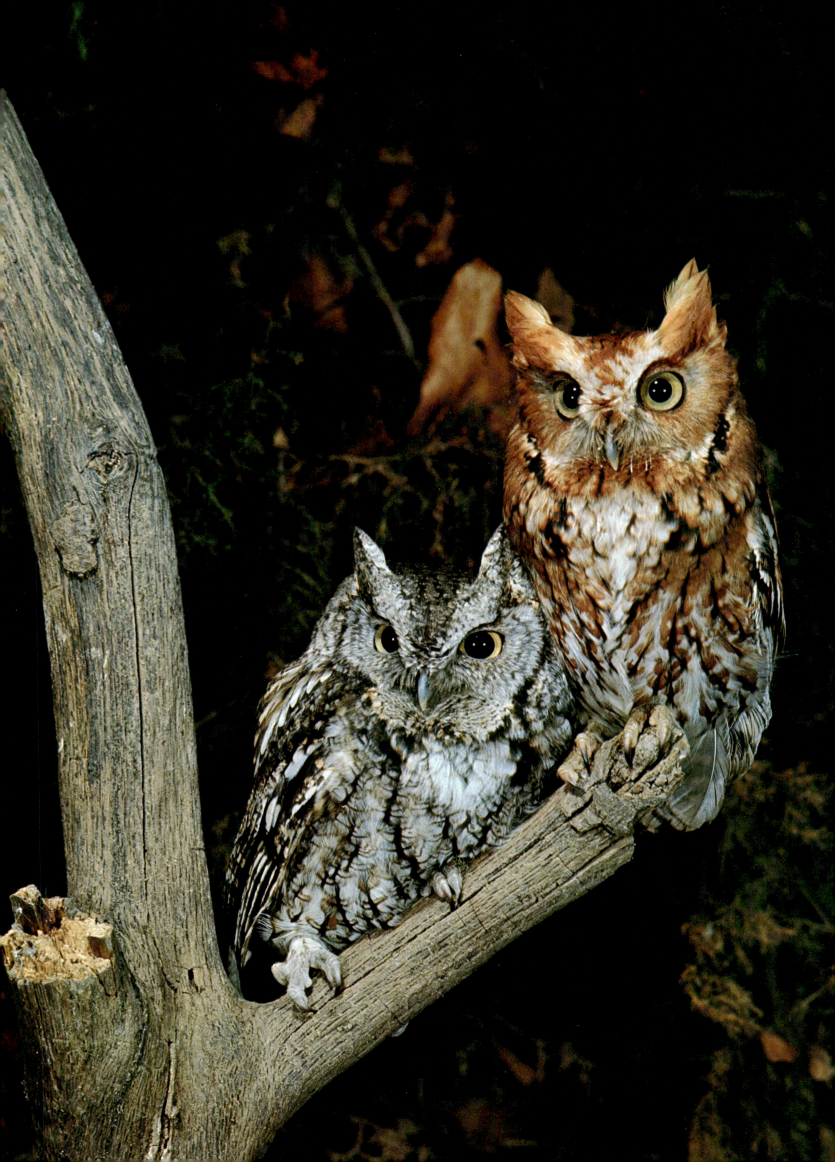

THE GREAT grey owl (*above*), with a wingspread of 5 feet, is among the largest of all North American owls. It is fiercely protective of its young and intruders approaching its nest risk serious lacerations from talons so sharp they have been known to blind people. The great horned owl (*opposite, above*), as a species, survives in the pine forests, the desert, the mangrove swamps and the tropical rain forests of the American continents. This bird feeds on all available small mammals—with a preference for hares in the north—while further south it supplements this diet with snakes. Among the best mousers of all (*opposite, below*) is the short-eared owl.

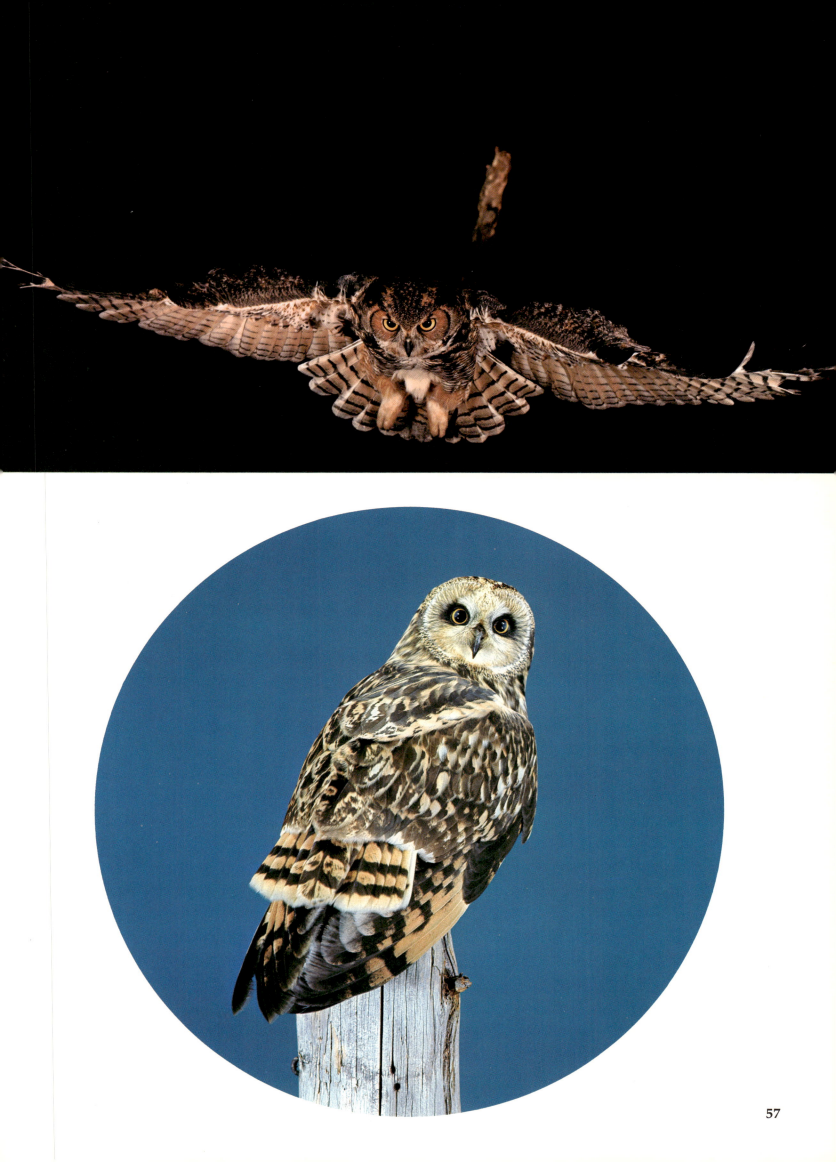

THOSE WHO ENJOY decorating a mantelpiece or a shelf with owls are not always naturalists. Therefore, they need not worry about the accuracy of the maker's interpretation of the original. Rather, it is expression and character that count in this popular collector's item. Sometimes, as in the owl (*left*) which is the work of a contemporary but anonymous Balinese, it is possible to speculate that the largish ears of the Oriental scops owl may have inspired the commanding ears of this wooden bird. But its tropical plummage recalls the parrot, not the sober owl. An Indian of the Chochiti Pueblo of New Mexico has also added fanciful touches of color to his version (*below, left*) of the elf owl. This tiny bird—less than 6 inches long—inhabits the saguaro cactus, usurping holes made by woodpeckers. The white ceramic bird (*below*) presents a straightforward decorativeness, whereas the imaginative Mexican who made the papier-mâche figure (*opposite*) embellished the breast of his owl with exotic birds.

LEFT: Courtesy, The Brooklyn Museum Gift Shop, New York.
BELOW AND OPPOSITE: Courtesy, General Cigar and Tobacco Co., Division of Culbro Corp.

Owls for the Mantelpiece

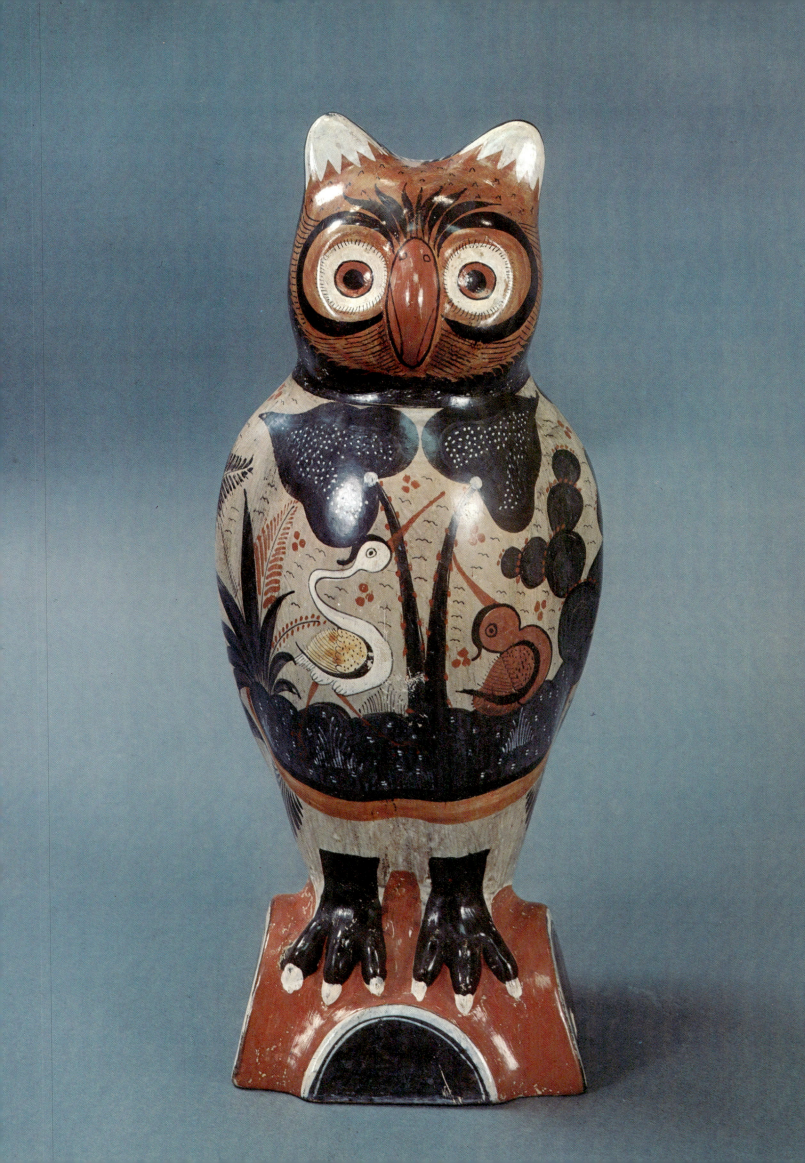

FROM MAINE to Mexico, from the simple to the sophisticated, the owl continues to be cast in all varieties of roles. The stoneware screech owl (*right*) originated in the woods of Maine. The owl from Tonala, Mexico, (*below*) is the work of the well-known potter Jorge Wilmot, who takes traditional Mexican floral patterns and weds them to Oriental shapes in the many owls he makes. The opulent owl (*opposite*), swathed in a thousand pheasant feathers, was designed in New York City.

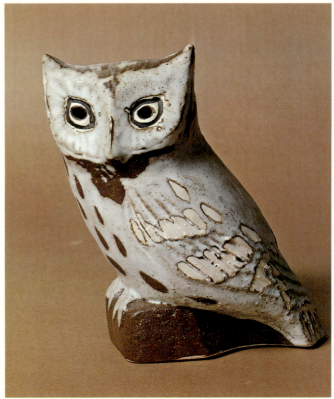

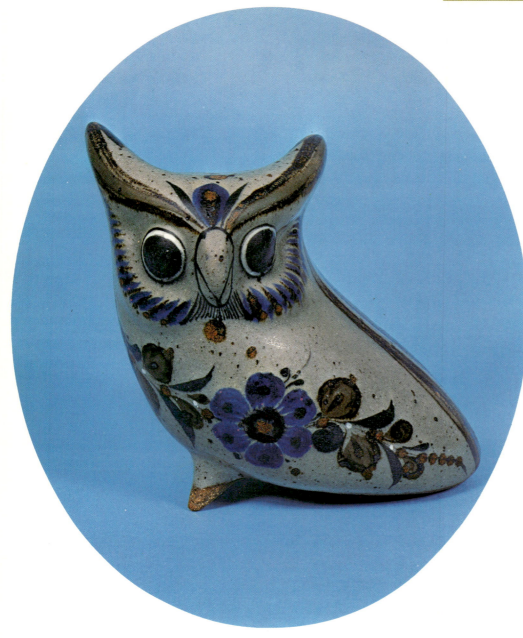

LEFT: Courtesy, the United Nations Gift Center.
ABOVE: Courtesy, Robin's Nest, Brookfield, Conn; Andersen Design Studio, East Booth Bay, Maine.
OPPOSITE: Courtesy, Paul Bellardo and Jeremie Hawley, Bellardo Inc., New York, photograph by Otto Maya

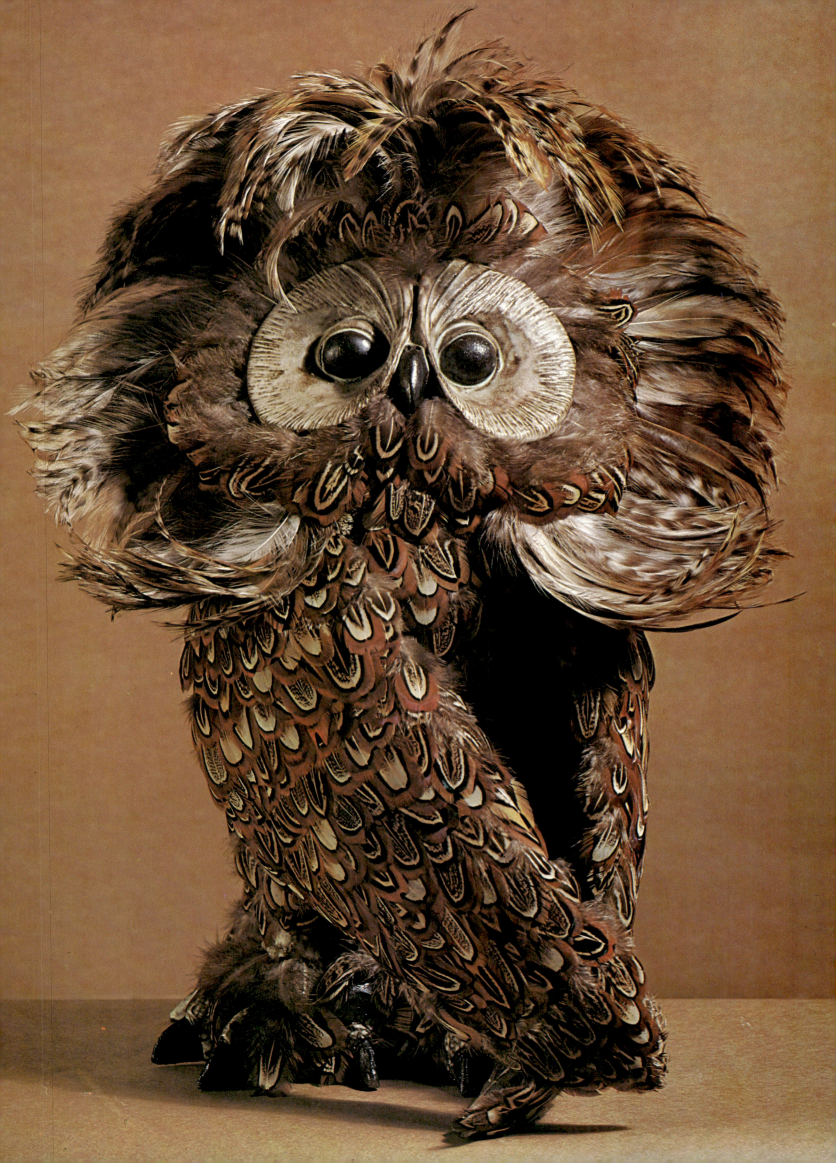

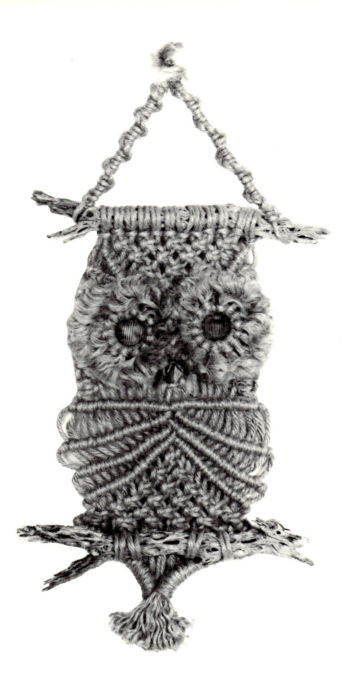

Owl Eyes to Gaze from Walls

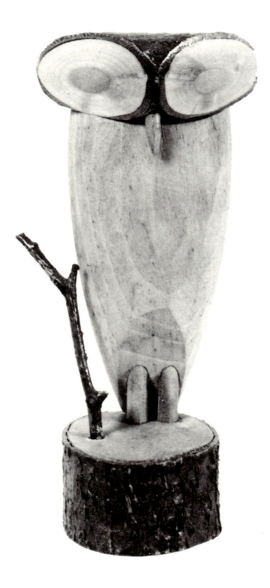

WHATEVER THE fashionable hobby of the moment, the universal attraction of owls insures that they will be a part of it. So, too, with macrame. Once used solely to decorate linens, the art of macrame which originated in Genoa, Italy, has now spread throughout the world and has many ornamental uses. The three hangings (*opposite*) were made in Taiwan of jute, some of which has been dyed brown or orange to achieve a variety of colors. The owl (*above*) was made in Phoenix, Arizona, and has cactus wood for crossbars. The wise-looking, wooden owl (*right*) stands as a reminder that traditional material for the creation of owls is still as good as new.

ABOVE: Courtesy, Robin's Nest, Brookfield, Conn.
RIGHT: Private Collection.
OPPOSITE: Courtesy, Trim Corporation of America, New York.

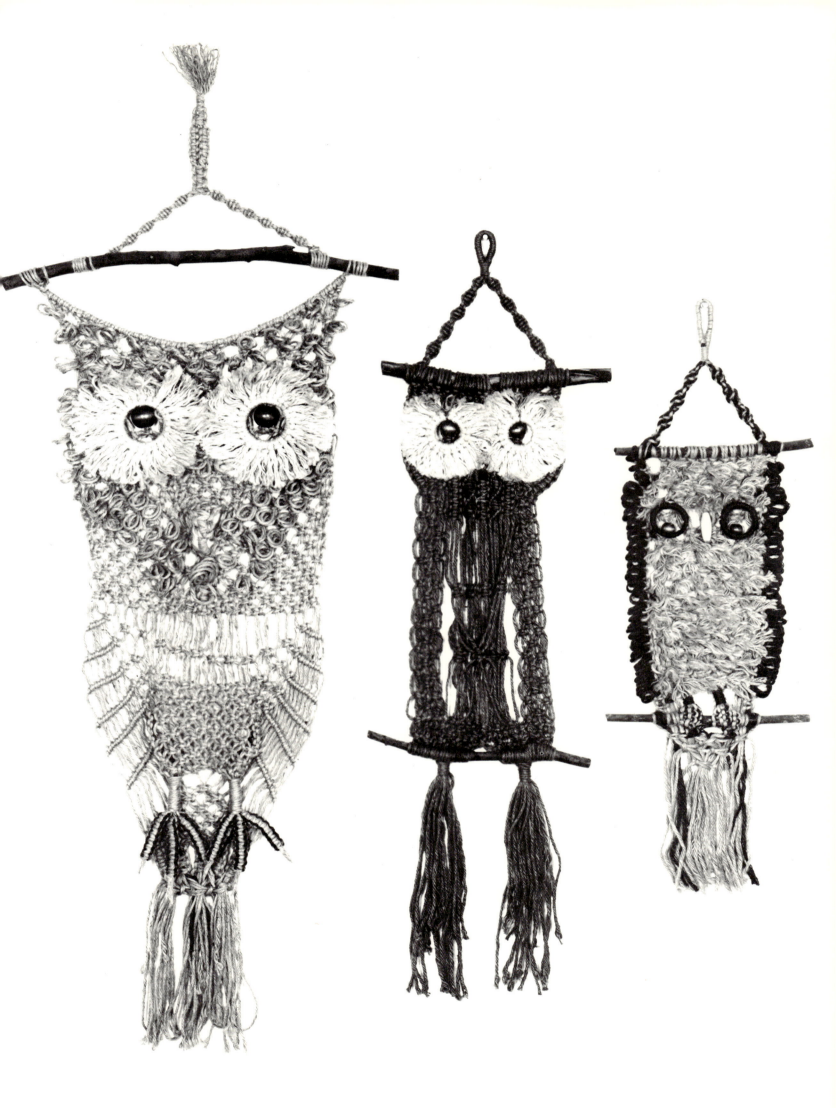

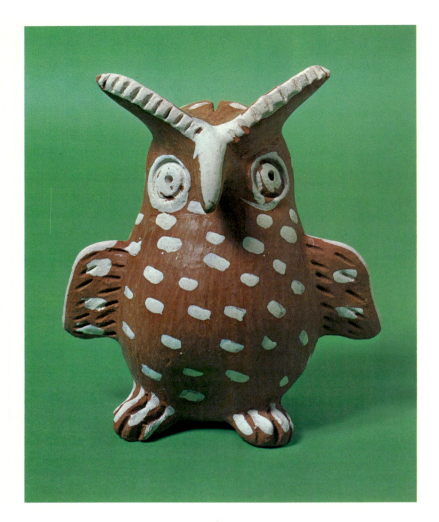

MYTH AND superstition which have so often cast the owl as a symbol of darkness, have also credited the bird with benign, healing qualities. In classical times it was thought that an owl egg fed to a child insured lifelong sobriety, in England that the egg cured whooping couth. Primitive peoples everywhere have used the carcass of the owl to ward off sickness, and in parts of Japan a wooden owl nailed to the door was believed to end famine and plague. If these beliefs have now died, the custom of making owls as folk art continues. The owl from Japan (*opposite*) is shaved from a single piece of wood; the vivid green owl (*below*) is Indonesian; and the big-eared, earthenware owl (*left*) is sold in the country markets of Guatamala.

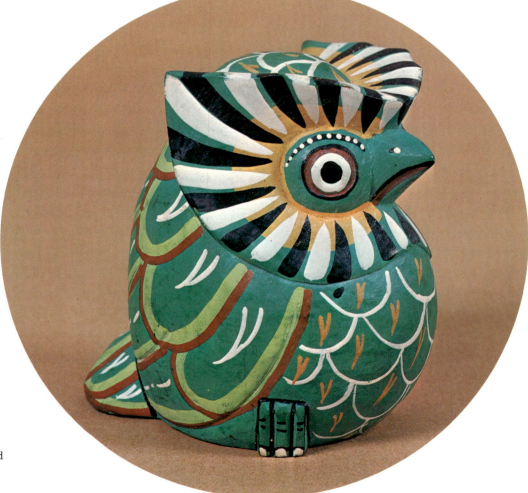

ABOVE AND OPPOSITE: Courtesy, the United
 Nations Gift Center.
RIGHT: Courtesy, The Brooklyn Museum
 Gift Shop, New York.

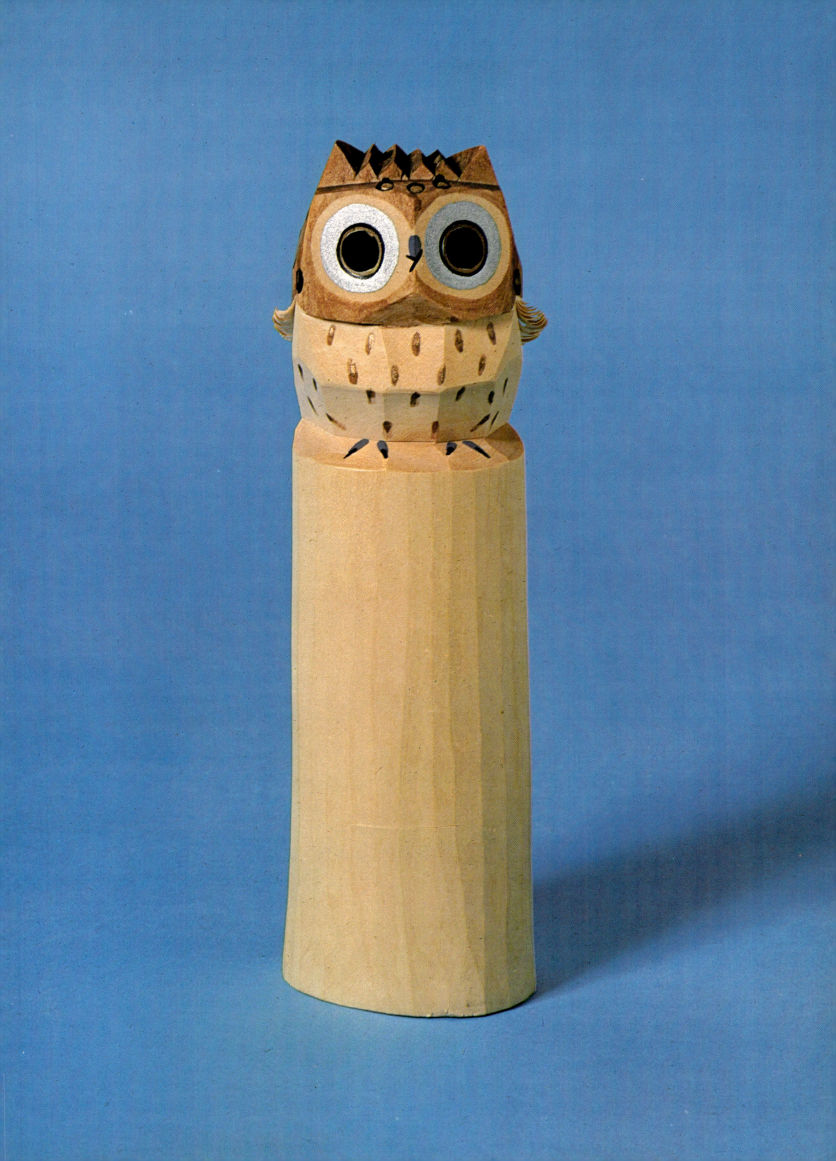

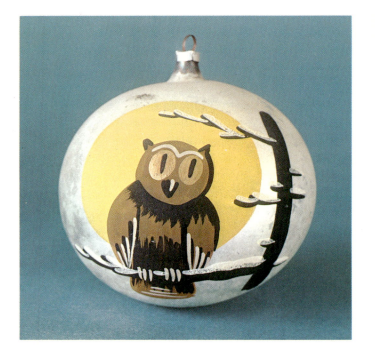

PRESENTING a purely practical article in the guise of an owl is a device favored by many, possibly because the bird's shape adapts easily to an object. The yellow, blue-nosed owl from Guatamala (*opposite*) is actually a coin bank; the Japanese craftsman transformed his metal bird (*opposite, below*) into a casing for a hanging lamp. From Edwardian England comes a washbasin (*below*) set with ewer and soap dishes in the shape of owls. In Czechoslovakia, the owl (*above*) adorns a Christmas tree bauble.

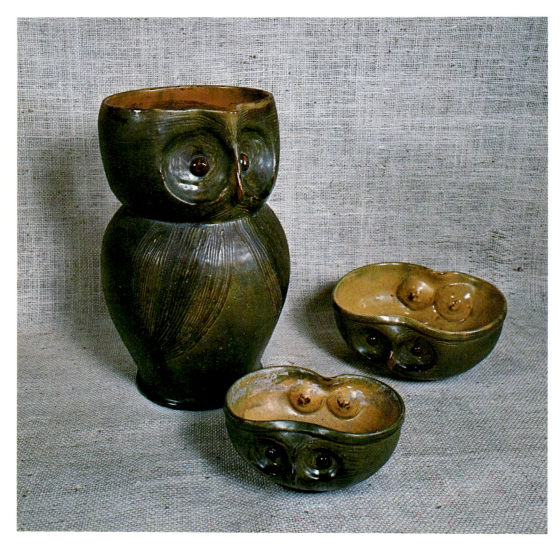

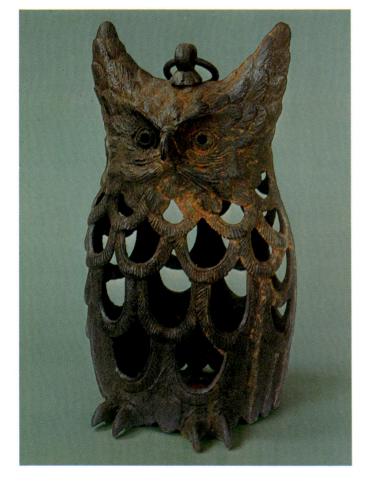

OPPOSITE AND LEFT: Courtesy, General Cigar and Tobacco Corp., Division of Culbro Corp.
OPPOSITE, BELOW: Courtesy, Henry Coger, John Bihler, Ashely Falls, Mass.
ABOVE: Courtesy, the United Nations Gift Center.

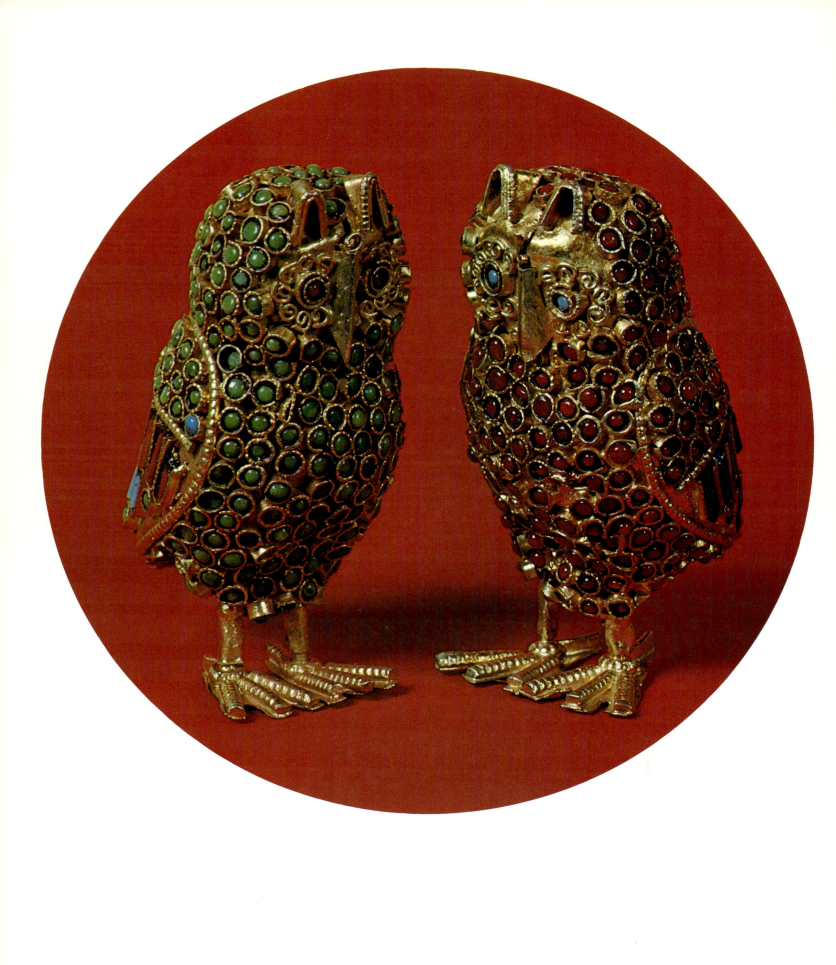

ENGAGED IN friendly dialogue are two little owls (*opposite*) from Nepal. They are handmade of bronze and encrusted with colorful stone chips, a style used in the decoration of temples in Nepal for centuries. The mother and child (*below*) huddled together have been carved from a single piece of textured soapstone to symbolize maternal protectiveness.

OPPOSITE: Courtesy, the United Nations Gift Center.
BELOW: Courtesy, the Rachel Seymour Owl Collection, photograph by Bernie Cleff.

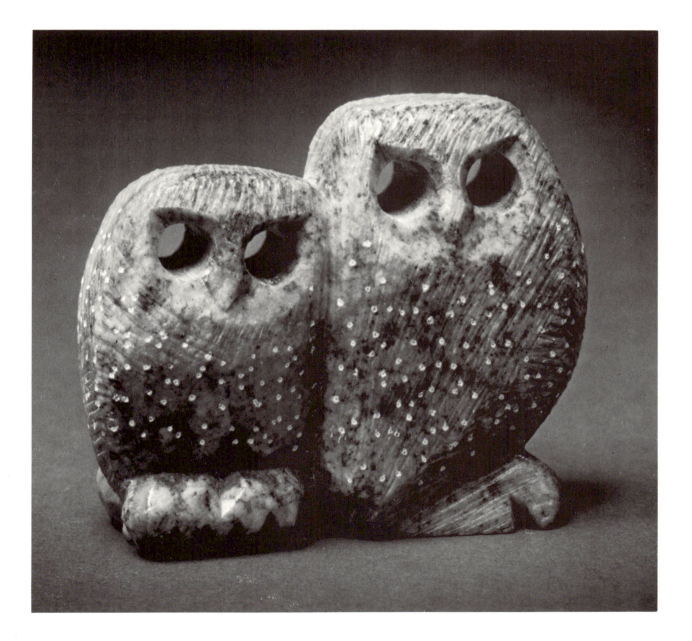

**What has been said about
THE OWL**

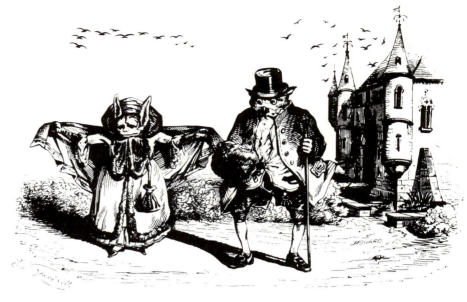

And yesterday the bird of night did sit
Even at noonday, upon the market-place,
Hooting and shrieking.

 —WILLIAM SHAKESPEARE (1564-1616)
 Julius Caesar Act I, scene iii

O, when the night falls, and roosts the fowl,
Then, then, is the reign of the Horned Owl!

 —BARRY CORNWALL (1787-1875)
 "The Owl"

A Faulcon towring in her pride of place,
Was by a Mousing Owle hawkd at, and kill'd.

 —WILLIAM SHAKESPEARE
 Macbeth Act II, scene iv

The screech-owl, with ill-boding cry,
 Portends strange things, old women say;
Stops every fool that passes by,
 And frights the school-boy from his play.

 —LADY MARY (PIERREPONT)
 WORTLEY MONTAGU (1689-1762)
 "The Politicians"

Can grave and formal pass for wise
When men the solemn owl despise?

 —JOHN GAY (1665-1732)
 Fables: The Shepherd and the Philosopher

When cats run home and light is come, . . .
Alone and warming his five wits,
The white owl in the belfry sits.

 —ALFRED TENNYSON (1809-1892)
 "The Owl"

 The wailing owl
Screams solitary to the mournful moon.

 —DAVID MALLET (1705-1765)
 "Excursion"

Some warre with Reremise, for their leathern wings,
To make my small Elves coates, and some keepe backe
The clamorous Owle that nightly hoots and wonders
At our quaint spirits

 —WILLIAM SHAKESPEARE
 Midsummer Night's Dream Act II, scene ii

O you virtuous owle,
The wise Minerva's only fowle.

 —SIR PHILIP SIDNEY (1554-1586)
 "A Remedy for Love"

When roasted Crabs hisse in the bowle,
Then nightly sings the staring Owle,
Tu-whit to who:
 A merrie note,
 While greasie Joan doth keel the pot.

 —WILLIAM SHAKESPEARE
 Loves Labour's Lost
 Act V, scene ii

"I am like a pelican of the wilderness:
I am like an owl in the desert."

 —Psalms 102:6

ABOVE AND OPPOSITE, ABOVE: In his book, *Album des Bêtes*, the
 Frenchman J.J. Grandville (1803-1847) made good use of
 the owl when poking fun at human foibles.

And he that will not fight for such a hope
Goe home to bed, and like the Owle by day,
If he arise, be mock'd and wondred at.

 —WILLIAM SHAKESPEARE
 Henry VI, Part 3, Act V, scene iv

The Owle shriek'd at thy birth, an evil signe,
The Night-Crow cry'de, aboding lucklesse time

 —WILLIAM SHAKESPEARE
 Henry VI, Part 3, Act V, scene vi

I am a brother to dragons, and a
companion to owls.

 —Job 30:29

Where the bee sucks, there suck I;
In a cowslip's bell I lie.
There I couch when owls do cry.

 —WILLIAM SHAKESPEARE
 The Tempest Act IV, scene i

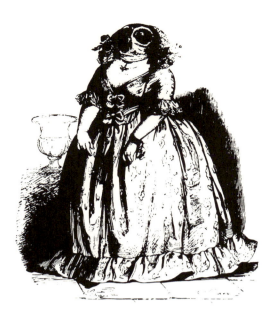

Save that from yonder ivy-mantled tow'r
The moping owl does to the moon complain.

 —THOMAS GRAY (1716-1777)
 "Elegy in a Country Churchyard"

A wise old owl sat on an oak,
The more he saw the less he spoke;
The less he spoke the more he heard:
Why aren't we like that wise old bird?

 —EDWARD HERSEY RICHARDS (1874-?)
 "A Wise Old Owl"

In Which Eeyore Loses a Tail and Pooh Finds One

"And if anyone knows anything about anything," said Bear to himself, "it's Owl who knows something about something," he said, "or my name's not Winnie-the-Pooh," he said. "Which it is," he added. "So there you are."

Owl lived at The Chestnuts, an old-world residence of great charm, which was grander than anybody else's, or seemed so to Bear, because it had both a knocker *and* a bell-pull. Underneath the knocker there was a notice which said:

PLES RING IF AN RNSER IS REQIRD.

Underneath the bell-pull there was a notice which said:

PLEZ CNOKE IF AN RNSR IS NOT REQID.

These notices had been written by Christopher Robin, who was the only one in the forest who could spell; for Owl, wise though he was in many ways, able to read and write and spell his own name WOL, yet somehow went all to pieces over delicate words like MEASLES and BUTTERED TOAST.

 —A.A. MILNE (1882-1956) from *Winnie-the-Pooh,*
 illustrated by Ernest H. Shepard
 Copyright 1926 by E.P. Dutton; renewal © 1954 A.A. Milne.
 Reprinted by permission of E.P. Dutton.

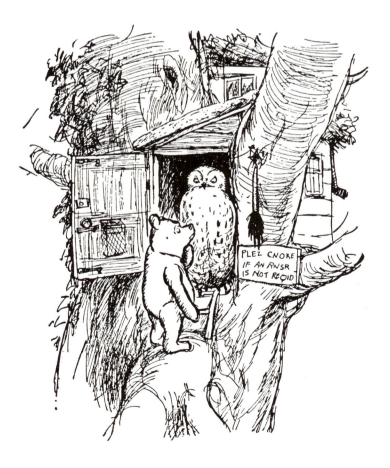

A serious writer is not to be confused with a solemn writer. A serious writer may be a hawk or a buzzard or even a popinjay, but a solemn writer is always a bloody owl.

—ERNEST HEMINGWAY (1899-1961)
Death in the Afternoon Chapter 16

Therefore in vaine for mee to bring owles to Athens, or add water to the large sea of your rare learning.

—SIR JOHN HARINGTON, (1561-1612)
trans., *Orlando Furioso* Book xl

Hearke, peace: it was the Owle that shriek'd,
The fatall Bell-man, which gives the stern'st good-night.

—WILLIAM SHAKESPEARE
Macbeth Act II, scene ii

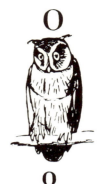

O was a little owl,
 Owly,
 Prowly,
 Howly
 Owly
Browny fowly
Little Owl!

—From Edward Lear's
Nonsense Alphabets

ACKNOWLEDGMENTS

The editors would like to acknowledge the help of the following people and institutions in the preparation of this book:

Pennsylvania Academy of the Fine Arts
Philadelphia, Pa.
Miss Pamela Lajeunesse

The New-York Historical Society
New York, N.Y.

The Metropolitan Museum of Art
New York, N.Y.

The Museum of the American Indian,
 Heye Foundation
New York, N.Y.
 Photographic staff

The Art Institute of Chicago
Chicago, Ill.

The Field Museum of Natural History
Chicago, Ill.

The Newark Museum
Newark, N.J.
Miss Barbara Lipton

The Museum of Fine Arts
Boston, Mass.

Wadsworth Atheneum
Hartford, Conn.
Mr. David Parrish

The Henry Francis du Pont Winterthur
 Museum
Delaware
Mrs. Karol A. Schmiegel

The National Gallery of Art
Washington, D.C.
Mr. Ira Bartfield

The Numismatic Society
New York, N.Y.

Shelburne Museum
Shelburne, Vt.
Miss Margot C. Vaughan

Yale University Art Gallery
New Haven, Conn.

Philadelphia Museum of Art
Philadelphia, Pa.

Mr. C.K. May
for the West Baffin Eskimo
 Co-operative Ltd.
Cape Dorset, Canada

Mr. Leon Lippel
Lippel Gallery
Montreal, Canada

United Nations Gift Center
United Nations, New York
Miss June Henneberger

America Hurrah
New York, N.Y.
Mr. Joel Kopp

Miss Florence Sterling
Miss Eileen Hunt
Bridgehampton, N.Y.

Mr. George E. Schoellkopf
Mr. David Pettigrew
New York, N.Y.

Mr. John Bihler
Mr. Henry Coger
Ashley Falls, Mass.

Mr. Harold Corbin
Three Raven Antiques
Falls Village, Conn.

Robin's Nest
Brookfield Center, Conn.

Mr. Frederick J. Schlutow
The Greenwich Workshop
Fairfield, Conn.

Mr. Randy Rose
Far Eastern Arts Inc.
New York, N.Y.

Mrs. Mary S. Leahy
Bryn Mawr College
Bryn Mawr, Pa.

Mr. Paul Bellardo
New York, N.Y.

Mrs. Penelope Bradford
Amagansett, N.Y.

Mr. and Mrs. Jacob M. Kaplan
New York, N.Y.

Mrs. James Thurber
New York, N.Y.

Mr. Leonard Shortall
New York, N.Y.

Mr. Harold Edeson
Culbro Corporation
New York, N.Y.

Mr. Ray Caputo
Trim Corporation of America
New York, N.Y.